Doodle Trees & Happy Bees

Create Playful Art

Kim Anderson

NORTH LIGHT BOOKS
CINCINNATI, OHIO
clothpaperscissors.com

D1302890

Contents

Chapter
1

Chapter
3

Chapter
4

Chapter
2

An Introduction

Finding Harmonious Balance

Creating balance in our lives is so important to our well-being but also hard to find in this fast-paced world of ours. However, I truly believe that being creative in some way can make our lives more harmonious and fulfilled. Whether it's painting, cooking, making music, gardening or interior design—even if that's just you rearranging the living room for the third time. They are all forms of being creative which gives us the wonderful feeling of personal achievement along with the rewards of sharing with our family, friends, peers and even the world via the World Wide Web. We are so lucky to find like-minded people with whom we can share our interests, creations, images and stories almost instantly on social media around the world. This feeling of connection with like-minded people can be rewarding and gratifying, bringing about a feeling of contentment and balance in your life.

Remember that feeling when you were a child and you would paint a picture or make a fort in your room? It was the process that was so rewarding as it was something you were creating that you couldn't wait to share, show off or even give. That is magic! To create joy for others and for yourself while you create.

I am so excited I get to share my creative thoughts and techniques with you in this book! I hope to inspire your own art dreams with the story of my journey into the creative life and how I created my own harmonious balance and fulfillment with doodling and mixed media. I will always love food, music and rearranging furniture now and again, but my true passion in life is art! Working with a mixed media of pens, paints, collage and anything sparkly is what fills my life with joy and a good balance alongside my family and home.

So, with a smile on our faces a pen in our hand, let's create some happy artwork together. Enjoy the process, and let your doodles grow into something magical!

Balance
Comes in the moments
When you stand up for the life
You truly want for yourself,
By making choices that align
With that.

—Jena Coray

my sunshine

love

rainbow

love

dreams

flowers

you are my sunshine

love

create

magic

love

dreams

rose

love

laugh

rainbow love

love

Rainbow Dreams

may all you

6

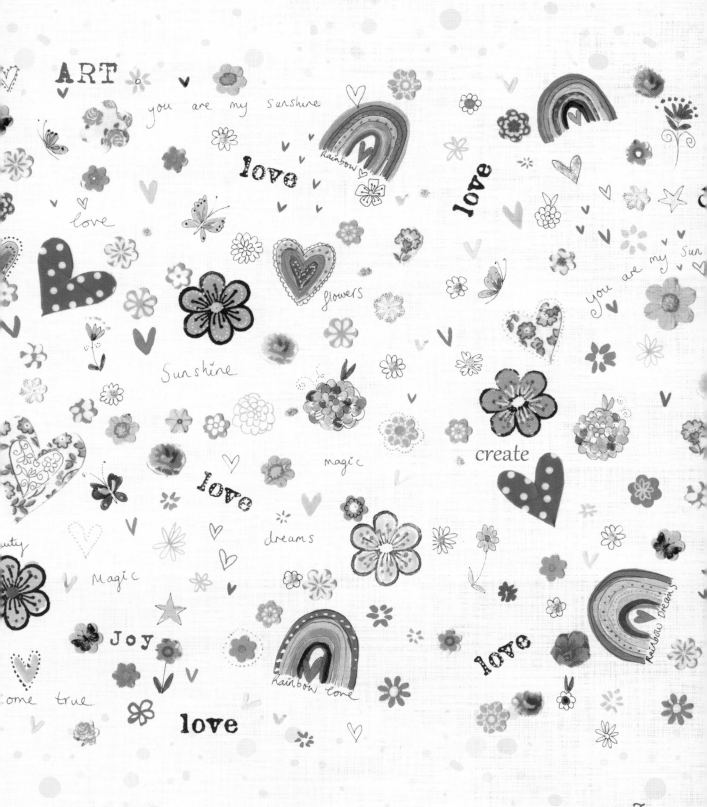

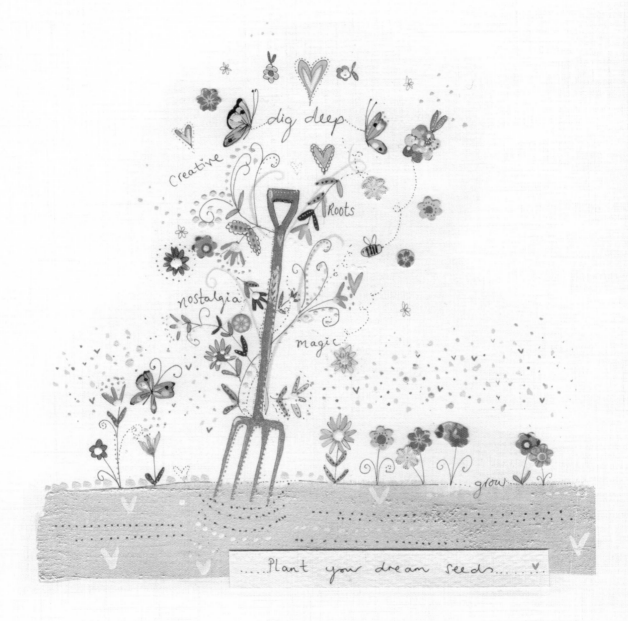

1

Roots
(Digging Deep)

Nostalgia, just like balance, also plays an important part in our creative lives. Again, comparing music or food with art, I think we can quickly be transported by certain sounds and tastes in our current everyday lives to a time when we were younger and carefree.

Feeling nostalgic is magical! It takes us back to happy times when we were children playing, learning and creating! It's a joyous memory to let our minds step back in time for a while and think about our creative beginnings.

I remember my parents were friends with a very talented fine artist and we had a few of his oil paintings on our walls. They were unusual, to say the least, and almost quite eerie but they didn't scare me as a child at all. Instead, I remember climbing on a chair so I could observe them more closely and I was quite fascinated by the details and textures; I was captivated!

I am certain this is when my creative seed started to grow and from then on most birthday gifts included a sketch pad and pencils. (Thanks, Mum!)

Every child is an artist. The problem is how to remain an artist once we grow up.

—Pablo Picasso

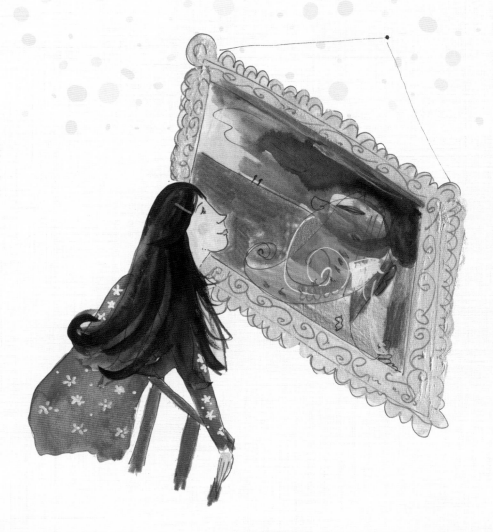

Can you think of a time and place you first started feeling creative as a child? Do you have any paintings or creations from when you were young? It's interesting to see how we have developed from our early artworks or how a certain interest has grown or been inspired to lead into something new creatively.

When I was about nine years old, I painted a floral for my nana and she still has it framed in her home. Whenever I see it, my heart warms that she still kept it after all this time and the fact that I still see that same little girl in myself today, using every color I possibly can in my artwork.

And although I still carry that young girl's passion in my heart, along the way since then I may have slightly strayed on my creative path (as many of us do) and tried different styles or mediums from when I was a child. It's our love for creating that drives our journey forward; to experiment and be inspired by things in our everyday life and the art materials we use.

It's also easy to get too serious about art as we become adults and forget about the joy it should give us— something we had no trouble remembering when we were younger and creating just for the fun of it. That's when we are creating our true art—when it brings us joy. Only you know what type of art or craft you love and truly enjoy making.

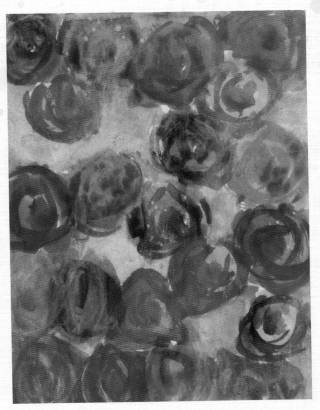

I have always loved to doodle and draw flowers in a very naïve way, just as I did when I was a child. My work has become slightly more refined over the years, of course, and has developed in different ways with the use of mixed media, but as I mentioned, it's inevitable to lose our way sometimes and we worry about how our art "should" look.

If you have ever felt like this, it's always good to get back to your roots and take some time to do what makes you happy. Use the colors you love, the materials you want to create with or just experiment with something new. Be a kid again and let loose without fear or worry about what others may think; it's usually these times we discover a new idea or we see how a simple doodle can inspire us to create a wonderful piece of art!

When I left my full-time design job, I felt very lost in my artwork because I had spent so much time working to deadlines and briefs, and creating art that was for someone else. But I also knew that the time had come to take a leap of faith and to go it alone in the art world.

Floral I painted for my nana when I was nine

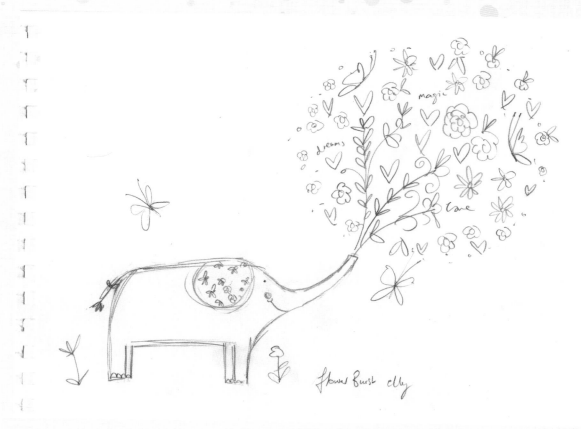

My first Elly sketch

So what did I do?

I sat with a pen and pad and doodled. I doodled a lot! Doodling is what I did as a child so I felt comfortable, the art felt familiar and I just trusted my head and hand. In my work as a greeting card designer, over the years I gained the experience of a variety of designs and techniques, and many of these illustrations are still used in my current work. So, I translated my experience into my way of creating designs—limitless and experimental—and this newfound creative freedom led me to blend my greeting-card design skills with my earlier roots of having fun with art and doodling freely. This is how my swirly trees and Elly elephants were originally created onto my notepad: by pure doodling, time to myself, no deadlines and allowing myself to just be free with my creativeness.

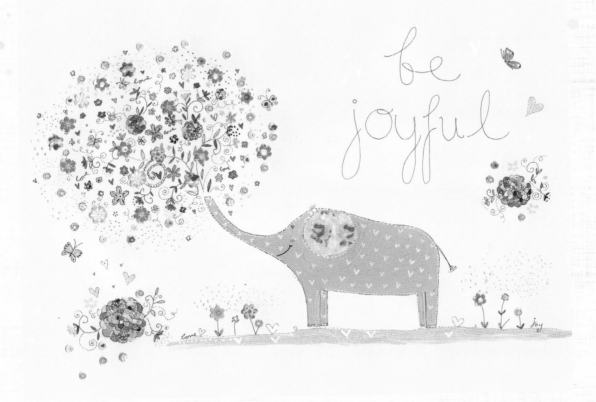

Elly today

Although I may have branched out in different directions since that time, my creativeness has still remained true to the art I made as a little girl because I soon found my way back to my roots, and now I always feel like my artwork is growing and blossoming with true joy.

Spend some time digging deep, and think about all those nostalgic times as a child when you were creating something wonderful and you weren't getting paid for it; it was just for you or a gift. You might just unearth some magic. You can then plant this creative seed of yours and see how it grows.

I Dream my painting, and then I paint my dream.

—Vincent van Gogh

Tools and Materials

I use a variety of mixed media for my artwork, so my tools and materials consist of a wide range of items from simple pens and paints to more specialized pieces like craft foil and glue pens.

I like to have lots of pretty pots on my desk to store all my pens and keep everything I need in easy sight and reach. Organization of your tools enables you to quickly know where everything is so your artwork can flow easily.

Gel pens and colored pencils

Inks, paints (including watercolor and acrylic) and brushes

Black pen, pencil, foil glue pen, pick-up pencil

Palette paper or a plastic palette

14

Craft glue

Craft punches in shapes you enjoy

Paper, canvas or even wood block

Craft foils

Glitter

Washi tapes

Fabric swatches

Glitter glue

Decorative papers

15

Paint and Doodle Experimenting

The fewer rules and restrictions we have in art, the better it is for us to find our natural flow and the easier it is to discover what tool works best in our hand. I personally love a thin pen to create doodles, but I also have days when I want to work big and get messy with paints and thicker marker pens. It's good to take the time to experiment with different pens or paints, either on their own or mixed together.

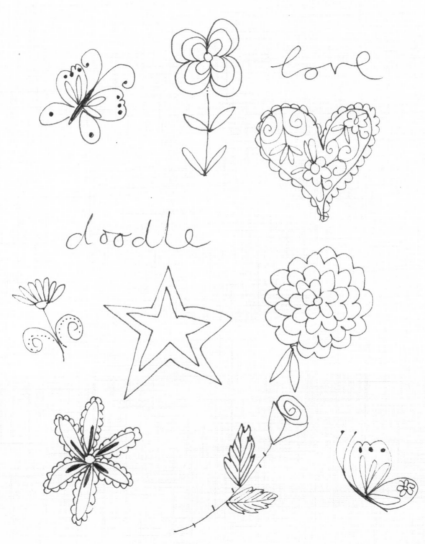

Doodling with different pens

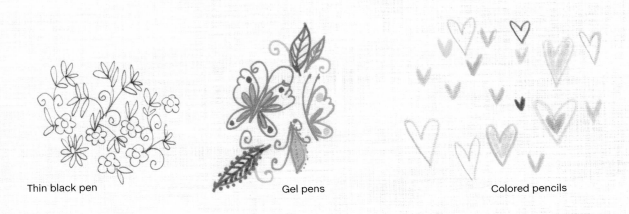

Thin black pen

Gel pens

Colored pencils

Try combining pens and pencils (and even paint) together!

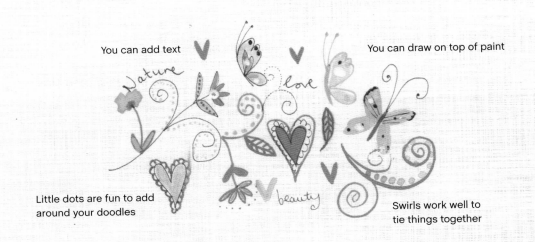

You can add text

You can draw on top of paint

Little dots are fun to add around your doodles

Swirls work well to tie things together

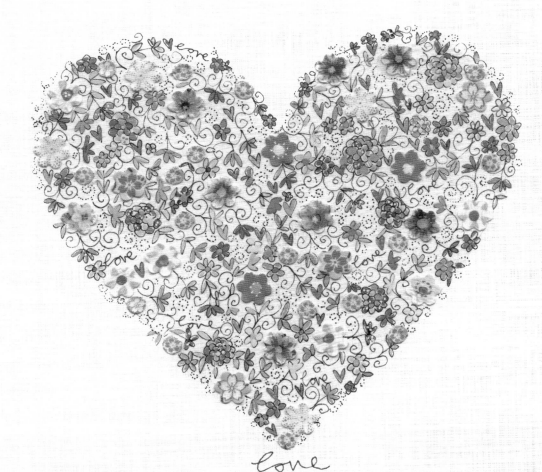

love

 # Filling in a shape with doodles

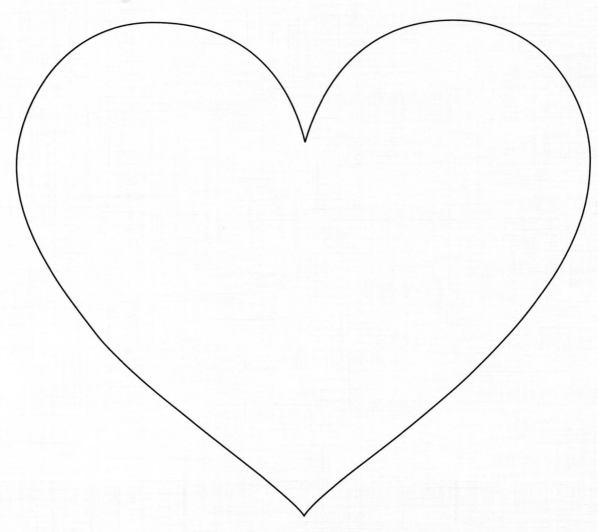

Now that you have experimented with doodles, you can use a basic shape such as a heart (trace this template if you like) to create your own beautiful doodle design. A good tip is to lightly pencil the shape and doodle around the edge first.

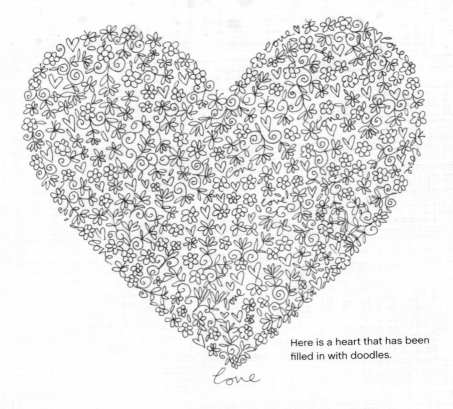

Here is a heart that has been filled in with doodles.

When doodling, it's a good idea to start with something you are comfortable drawing freely, such as a shape, like a heart, star or flower. Something so simple is not intimidating or difficult. You can give structure to your doodles by filling a shape in with repeated doodles. As you doodle over and over with the same shape you can start to make little changes to each one, such as its size, changing pens or colors, adding pattern or even words.

As you do this you will see your simple doodle become a design, which is really rewarding and exciting. This then gives us the confidence to experiment even further with our doodles. You will also discover your medium preference—maybe you love the way the gel pens flow or the intricacy you can create with a thin pen. This is the magic of creativity; this is how we unearth our own unique style, which we can then continue to evolve. These simple beginnings can grow into beautiful artworks if we trust our hand and experiment with different mediums.

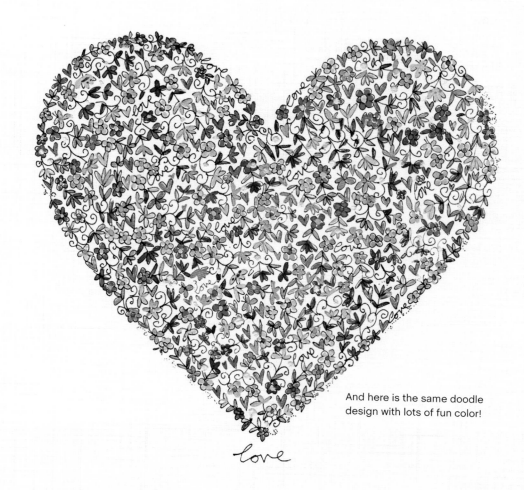

And here is the same doodle design with lots of fun color!

love

Repeating a Doodle

This technique of repeating a doodle is great fun and the perfect way to get into the doodling rhythm as doodling is all about simplicity, fun and letting go of restraints, allowing your art and hand to flow more naturally.

It's also quite therapeutic to doodle the same thing over and over again. Do you ever just doodle when you're on the phone? It's pure freedom with your hand and you tend to "switch off" for a while. This is also like coloring, which has become a big hit these days! It's good for us to relax and let our hands take over sometimes in something so simple yet creative.

In this Butterfly Tree design, which has since become a cross-stitch kit and published as a greeting card, I used a very thin pen and decided to draw a tree outline and fill it with butterflies. Although each butterfly is almost the same as the other, coloring them in makes them different.

To repeat a doodle, you don't have to draw a tree. The exercise is to let go and repeat the same icon all over, even if it's just on a sheet of paper with no shape at all. Without knowing it, you are also building up your own design art library with doodles you can use in other artwork.

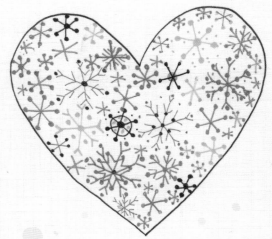

Here I have created a simple heart shape filled with repeated doodles of snowflakes in a variety of sizes and styles using gold and different hues of blues. Simple and quick to do yet very effective and perfect for a Christmas design, both male and female, or even a winter wedding or anniversary card or gift wrap design.

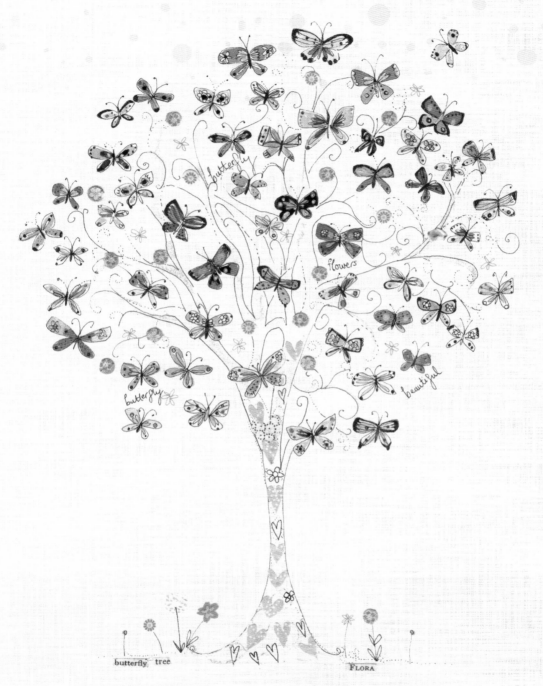

Experiment with different shapes. Here is a very simple
tree, filled in with butterflies, swirls and other small doodles.

Creating a Simple Tree

This design lets us explore the confines of our little doodles in a more organic and very forgiving shape. I often like to personalize trees as gifts for special occasions such as a wedding or the arrival of a new baby.

What You Need

PVA glue

art paper

punched-out flowers, cut-out fabric flowers and sequins/gems, etc.

glitter glues in different colors

white eraser

tracing paper and pencil

black waterproof pen, fine-point

foil glue pen

gold/silver foils, ink or paint

paints and pens of your choice

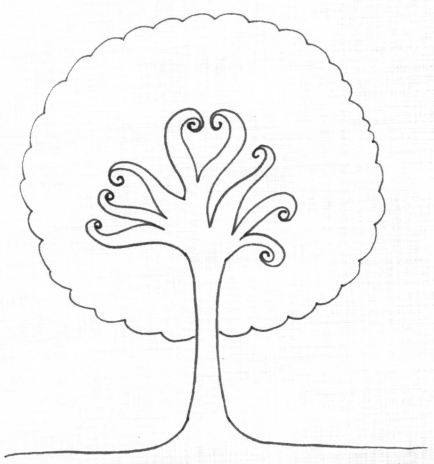

Drawing template

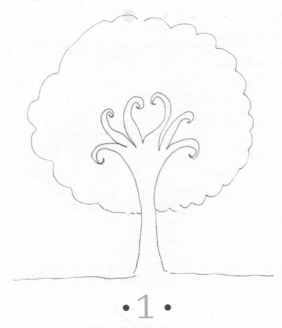

• 1 •

Place tracing paper over the tree template and trace it with a pencil. Place the traced tree facedown onto your art paper and rub over the penciled areas to transfer the tracing to your surface.

• 2 •

With your black pen, go over the trunk and branches but only do tiny dots around the circle of the tree shape. Once you have done this you can erase any pencil marks that remain.

*Top Tip

I always have a nice dry paintbrush to sweep away the rubbings to keep my art nice and clean!

• 3 •

Now for the fun! Be free and add whatever doodles you like. This could be anything: flowers, butterflies, bees, hearts, stars, words, names, rainbows and even animals at the base of your tree. Don't forget to add lots of lovely swirls for your branches! You could also focus on a theme for your tree such as a love tree, which could be filled with hearts, or a snow tree with snowflakes and stars. It's fun to make your tree unique with your own ideas.

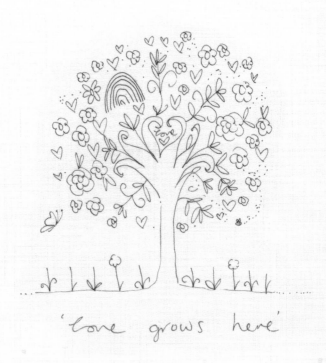

'love grows here'

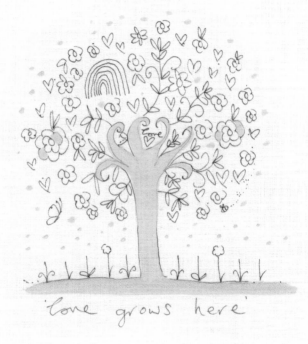

'love grows here'

Optional

Using the foiling technique shown in chapter 2 (*Adding Foils to Doodles*), use your foil glue pen to fill in the trunk, branches and ground area. I also add little spots in and around the tree and above the flowers. In place of foil you could also use gold or silver ink or paint.

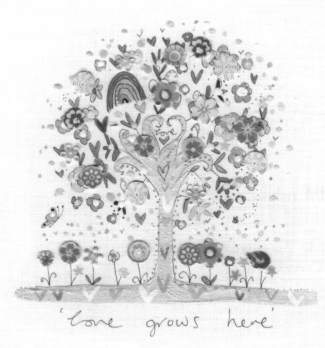

'love grows here'

• 5 •

Now it's time to add color to your doodles. This is always my favorite part and again, you can be as free and bold as you like! Your color palette could be pastels, brights or just a limited number of hues if you're creating a tree with a specific theme. If you decide to glue on bits of collage pieces, do this after your coloring is finished.

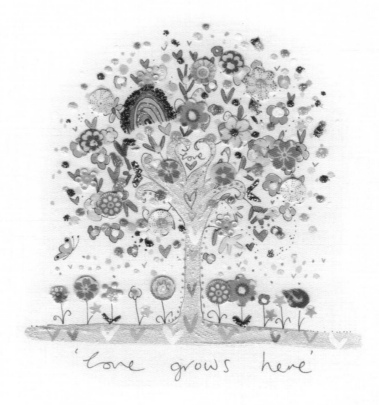

'love grows here'

• 6 •

Optional

Glitter time! If you're not familiar with using glitter, take a look at the *Using Glitter with Doodles* section in chapter 2. It's best to do this part last as the glitter glue takes a while to dry. I tend to add lots of glitter dots all over the tree in different colors and sometimes just to highlight certain areas such as a color in a rainbow or the green in the leaves.

Feel free to play around and see what effects you can make with the glitter glue!

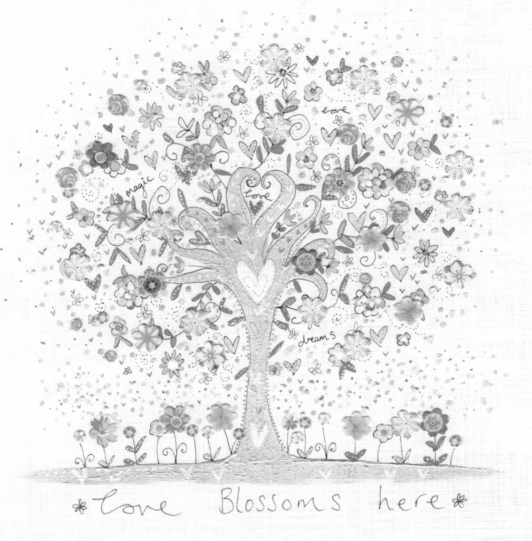

Love Blossoms here

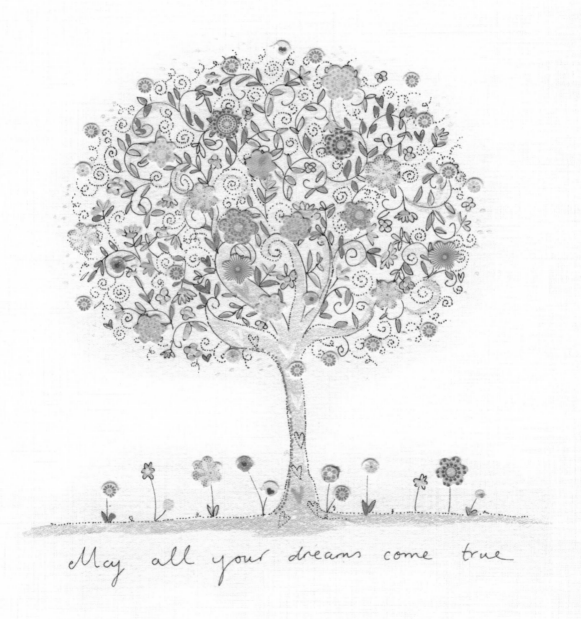

May all your dreams come true

2

Planting Seeds (Nurturing Dreams)

Growing and evolving in life is the most natural thing in the world. From the flowers and trees to the bees and fish in sea, the animals, our children, ourselves, our work and our dreams. Our dreams start small but will grow and continuously evolve, and we should nurture them all.

To evolve is also to learn, which we can pass on and share with others along the way. I strongly believe we should all share our findings and our stories, otherwise we would all be stuck and not quite sure of which direction we should go. What if Charles Darwin did not share his findings of evolution? Or your mom never taught you how to cook? It's all the big things and the small things that we learn from one another, past or present, that help you and myself progress in our lives.

In this chapter, you're going to learn to create many different doodle designs. Before starting each one, I think it's a good idea to have your art space completely ready, even if that's the kitchen table! You need to have all of your materials at hand in a good clean and clear spot to create your magic!

So, have your brushes, pens and paper set out with a jar of clean water for your paints, maybe a refreshment, some music and twinkling lights, too!

Some last things to consider: If you are creating your art on paper and you are thinking about framing it, remember not to use any embellishments that are too bulky—stick with flat sequins and stars. However, if you are using a canvas or wood panel, dimensional embellishments are great fun to stick on!

Okay, let's get creative!

*Allow yourself to grow
like wildflowers.*

—E.V.

Now, I'm no Charles Darwin nor can I cook as wonderfully as my mom. However, since graduating from art collage and following my dream of being an artist, I have discovered I am creative. There have been many ups and downs, but I believe that the mistakes that happen along the way are what help us truly evolve and live the creative lives we desire. If you can find your creative flow and trust it, magic can happen when you see your creativeness grow and evolve into artwork that will make you and others happy. This is what happened to my swirly trees; I let them naturally evolve from a fruit tree (get-well card) to a love tree, family tree commissions, sunshine trees, snow trees and now—my most popular—very sparkly dream trees.

The style has always remained the same, yet without me even trying, the trees have changed over time with small additions of the foiling for the trunk and branches, the glitter glue and embellishments. I love using my trees as an example of trusting your art. There was a time when I thought I should and must do something different every time I was in the studio. I think this way of thinking stemmed from my college days and time as a greeting card designer. I gave myself a hard time about it and tried different styles of artwork that were not as popular. So one day I thought, Kim, if you love creating the trees and it makes you and others happy, keep doing it! And I did, and like magic they evolved into sparkly pieces that became my best sellers. So, trust yourself and your art journey. Don't worry if you come to a crossroads or stop sign; sometimes that is actually a sign to take a break, reflect or have some doodle/relax time.

Nurture yourself and your creativity along with your dreams, whether that's being a full-time artist or playing with your art as a hobby that could grow into a business. It really is possible to allow your little seeds of dreams to at least sprout and see how they will grow. I have seen it with many artists on social media or read books about their stories. Nearly everyone is afraid of that very beginning bit—the believing-in-themselves part. But it's so comforting to know we have all felt like this, and it gives us the encouragement and inspiration that we can do it, too.

Showing the world (or even family and friends) your art is scary, but if it's what you love to do, just try to sow that first little seed. I feel very lucky that I have been able to encourage some artists to do this and it's amazing to watch their art hobby grow into a business.

If we remember that a tree or flower doesn't grow overnight and we can envision what that seed will be in time, we can envision our creative dreams. Start somewhere, enjoy it, play and let it evolve. Share it, learn from it and trust the journey as you never know where it may take you.

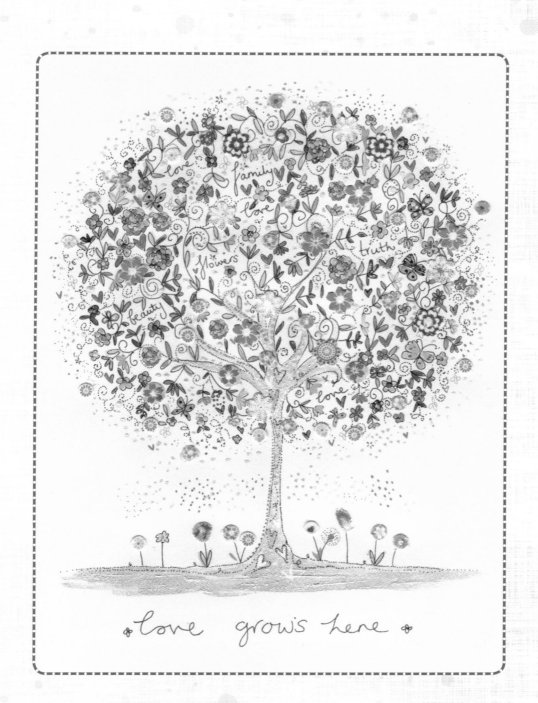

• love grows here •

Getting Into the Creative Zone

For a few years now, while working from my home studio, I have developed some funny habits before I can sit down and work properly. A bit like a football player or actor who has to wear a certain item of clothing or perform a particular ritual before they commence their game or show. Now, I don't need to wear a particular thing (but I do like to be loose and comfortable when working!) but I do have a standard routine and I feel out of sorts if certain things aren't done.

I'm pretty sure we all have little oddities of some kind or another in our working days. Once my son has gone to school, I pretty much have to have all the house chores done from dusting to vacuuming to laundry. It's almost like a messy house makes my head feel messy, and I cannot create like that at all; I need to feel serenity around me, and a tidy space really helps with that. To aid that serene feeling, I love to listen to something calm and relaxing, which for me comes in the form of nature programs such as David Attenborough. I don't need to watch them, just hear them. My desk space is always tidied the night before, as I love to sit down to a fresh clear area (and then make a mess!). Lighting a scented candle or turning on twinkly lights is a must, and I like to think that's my arty spiritual side, but in fact, I think that's just the girl in me!

I also love to have lots of cups of mint green tea throughout the day!

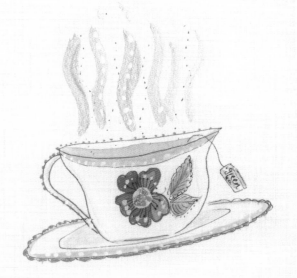

What are your creative rituals? Maybe it's a walk before work, some yoga, meditation or your favorite playlist. I know some artists who simply wait until the evening when all is still and the kids are in bed, then they feel ready to create. It's all about finding your magic time to sit down and be creative at your own speed. And when we have days that are hectic with crazy deadlines or family commitments, we can still find a little bit of magic and sparkle with the twinkly lights, but maybe just not as many cups of tea as we would like!

Now that you're in the zone, let's make some art!

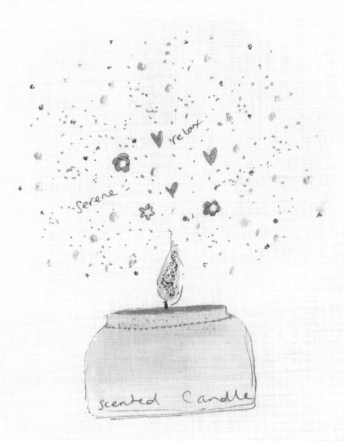

Adding Foils to Doodles

Foiling is so much fun and can turn your art into stunning, eye-catching pieces. Let's begin with some practice using your doodles.

foil art foil glue pen and waterproof pen or a pencil

What You Need

foil sheets in various colors

paper or card (something on the thicker side)

· 1 ·

Using your pen or pencil, have some fun creating doodles on your piece of paper. These can be as bold or intricate as you like. But remember, this is your time to experiment, so it's a good idea to try different doodles and patterns for your foiling.

*Top Tip

Patience is needed waiting for the glue to fully dry before adding the foil. This is a good time to prepare your punched-out flowers and get your colors ready for the next step.

Foil glue pens for foiling often come in various nib sizes and the fluid is usually a blue color so you can see it while applying it to the paper. Make sure your foil glue pen is flowing well by writing or pressing the nib on some scrap paper. Carefully go over your doodle lines with the foil glue pen or fill in entire areas of your art. Once finished, allow the glue to dry throughly until it becomes clear and tacky.

• 3 •

Take a bit of time to decide on your foil color or pattern for your artwork. For instance, you may want to use a sparkly silver for stars or a rainbow foil pattern for flowers. You can purchase foil kits that come with a variety of colors, which is perfect for this experimenting time.

Gently place your chosen foil over your artwork and rub all over the glued area, burnishing quite firmly. You can also cut the foil sheets into small pieces and choose sections of your artwork to do in different colors.

dreams

* If some of the foil has not adhered to your glued areas, just place the foil back down and press a bit harder in that area, then peel back again slowly.

dreams

• 5 •

Now for the exciting part! Gently peel back the foil to reveal your sparkly doodle art.

Embellishing Doodles with Punched Bits

Little punched shapes offer a fun way to spruce up your doodles and add a bit of texture and visual interest to your designs. I often use flower shapes, but any small shape works.

Washi tape (essentially decorative masking tape from Japan) has fast become my secret weapon for all the little flowers in my trees and heart artworks. It's so wonderful for any collage/mixed-media artwork as there are endless patterns, colors, widths and even sparkly and fabric ones!

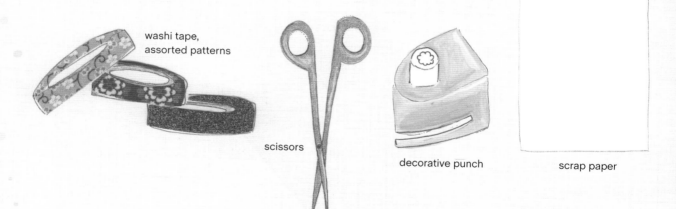

washi tape, assorted patterns

scissors

decorative punch

scrap paper

• 1 •

To make punching easier, begin by placing several strips of washi tape on a piece of paper.

• 2 •

Cut apart the strips of tape to make it easy to run them through your punches. With your first chosen craft punch—maybe a flower or circle punch—begin punching out multiple shapes. You may decide to switch punches on one pattern of tape or use one punch per pattern—it's up to you!

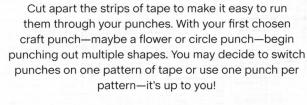

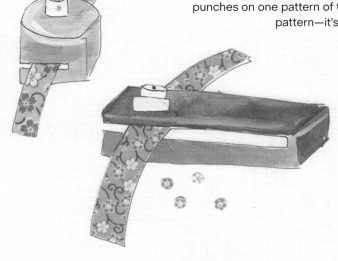

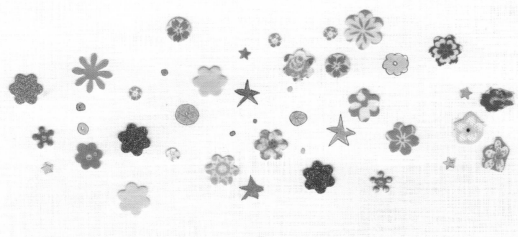

• 3 •

Continue until you have a nice pile of cute little shapes to add to your doodle art. Along with the washi tape you can cut out flowers from fabric and decorative papers. For extra sparkle in your art, throw in some sequins and gems, too.

PICK UP PENCIL

* Use a special 'pick-up' pencil for your small collage pieces.

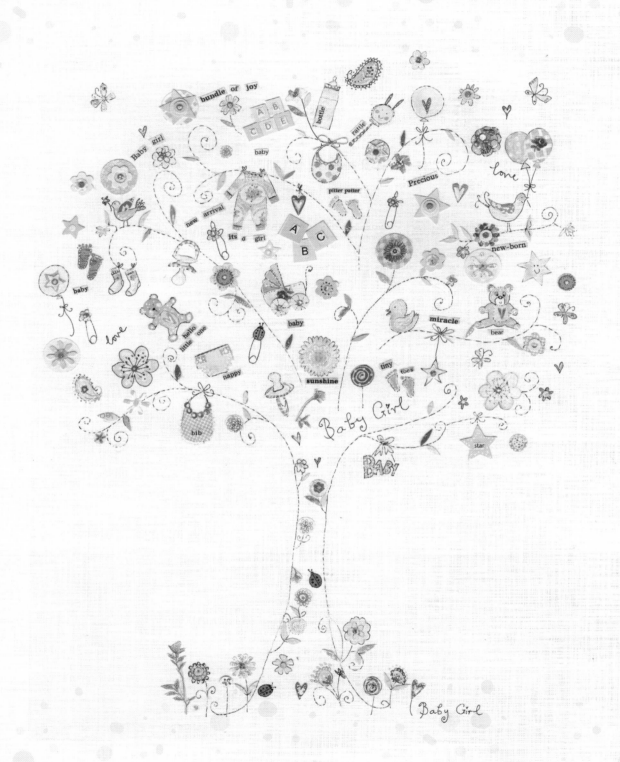

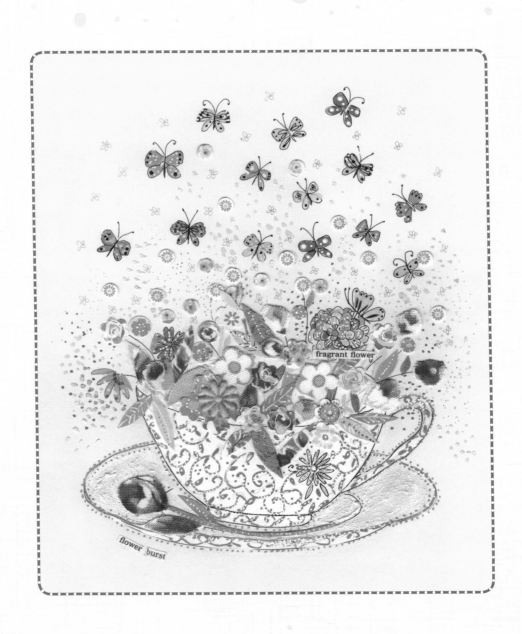

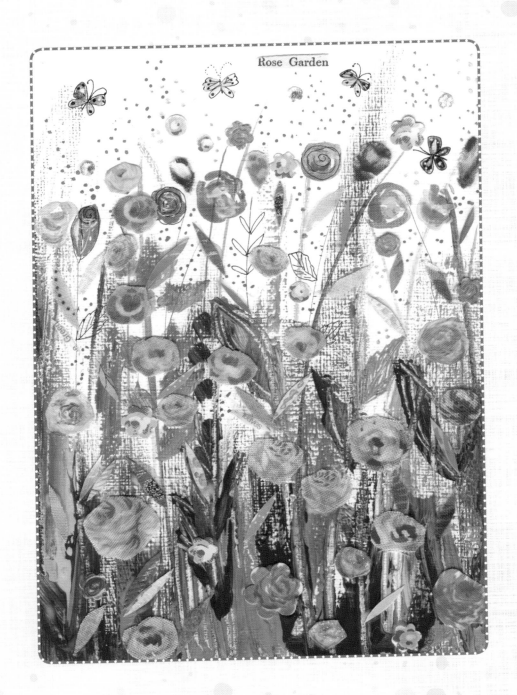

Rose Garden

Using Glitter with Doodles

Glitter glues are fun to use and come in lots of different colors. I tend to add glitter glue as the last element to my designs, as it takes the longest to dry. Have fun with your glitter glue. Try adding dots, accents of color and swirls. Experiment and see what ideas you can come up with!

If using glitter powder, follow the same steps as the foiling technique by using a foil glue pen. Always wait for the glue to cure to its tacky stage (not its still-wet stage) before you sprinkle the glitter on and gently rub it in. I find the glitter powder is brilliant for intricate parts of your art, such as stars and hearts, but you could do a whole tree trunk in glitter powder, too.

What You Need

art paper or wood panel

foil glue pen

pots of glitter powder

glitter glues (those with precision tips are best)

*A big brush is handy for sweeping away the excess glitter powder.

• 1 •

Begin by making simple dots—either with the glitter glue or with a foil glue pen and loose glitter.

• 2 •

Next, try making small but simple shapes such as short lines on leaves and stems or larger circles.

• 3 •

When you're all warmed up, experiment and play with swirls, hearts, stars or any other shape that makes you smile.

*Remember to let the foil glue pen cure before adding glitter.

Creating an Elly the Elephant

Elly is close to my heart because she sat so patiently in my sketch book while I finished my full-time design job. Elephants are a symbol of good luck! Elly has since been created as a greeting card and cross-stitch card.

What You Need

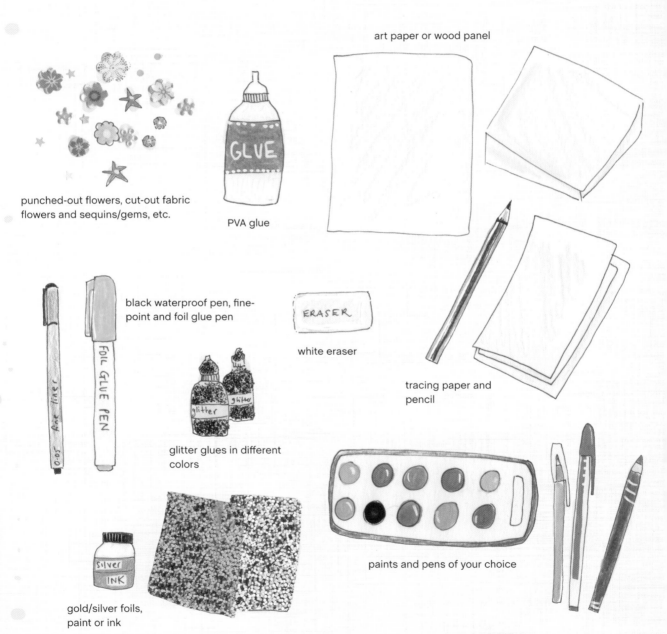

art paper or wood panel

punched-out flowers, cut-out fabric flowers and sequins/gems, etc.

PVA glue

black waterproof pen, fine-point and foil glue pen

white eraser

tracing paper and pencil

glitter glues in different colors

paints and pens of your choice

gold/silver foils, paint or ink

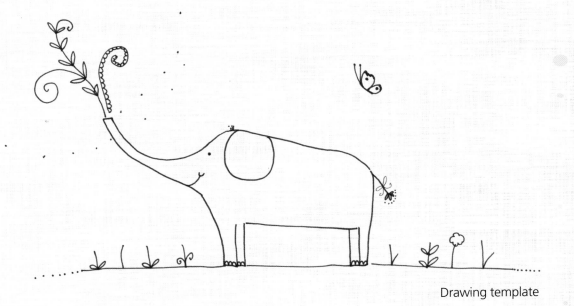

Drawing template

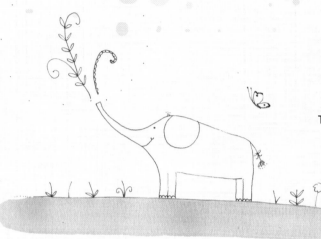

• 1 •

Trace the Elly template and transfer onto your paper or chosen surface, such as wood or canvas.

Use a black pen to define the outlines of the tracing.

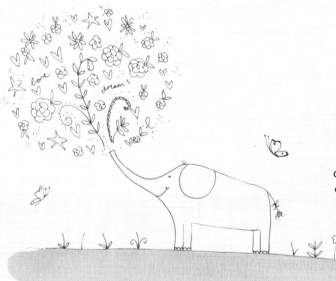

• 2 •

Using the circle of dots as a guideline, start to doodle freely in and around this area to create Elly's "flower shower." At this stage you can add extras of your own on the design such as more butterflies, maybe birds, or even trace Elly again and have two elephants together.

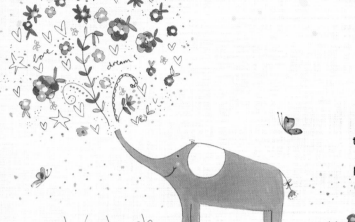

• 3 •

I like to paint Elly in a nice soft blue, but you can try a different color, such as a bright pink or a sunshine yellow. I like to use a mixture of gel pens and paint for the flower-shower doodles, adding little dots all around it and above the flowers on the ground. This makes it look like a spray of color is bursting all over the design. (If you are going to add foil to the hearts and stars you can leave these blank.)

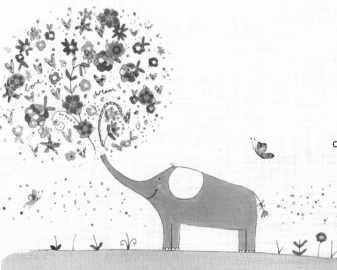

• 4 •

Lots of punched-out flowers are fun to add to this design; after all it is a flower shower! This is a good time to do your foiling, if you're going to use foil.

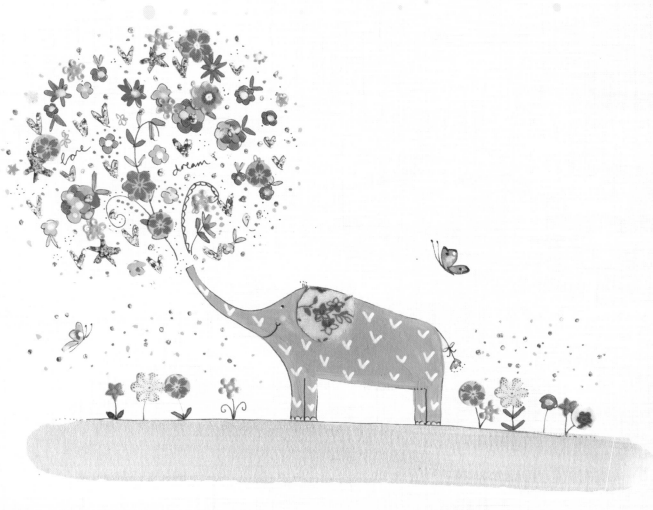

• 5 •

You can paint Elly's ear, of course, but what I like to do is attach a fabric ear. As with the Wishing Whale, it's nice to add little white hearts on Elly. Sometimes I do little hearts in foil as well. Don't forget to add flower heads to the stalks on the ground, too!

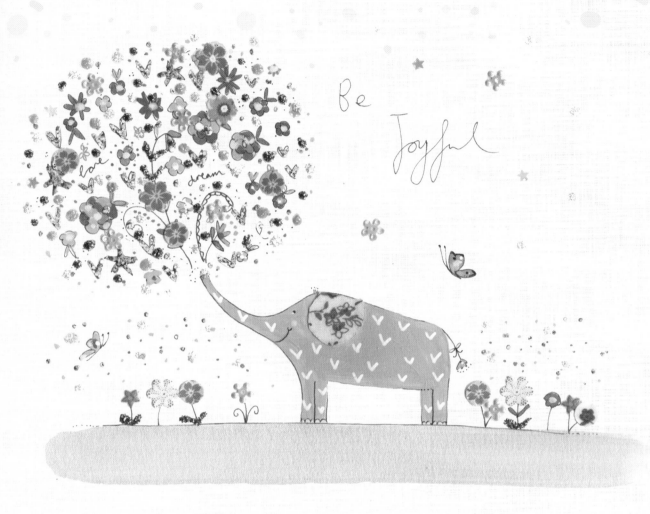

· 6 ·

Optional

For the finishing touch on Elly, you can dot about some glitter on the flower shower and around the flowers. When there are flowers on the ground I like to use green glitter on the leaves, but these are just little habits I have picked up along the way with my designs. Be creative in your own way.

Add your own message or words beside Elly! You could personalize her with a new name!

Creating a Wishing Whale

Like my Elly, the whale design had been in my head for a while. When I finally created my Wishing Whale I used the same idea as Elly with the flower shower. It's a simple illustration but full of fun and color.

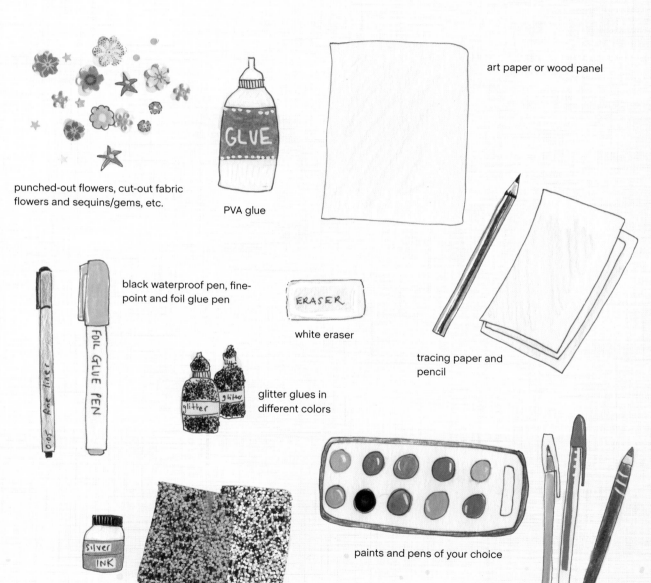

punched-out flowers, cut-out fabric flowers and sequins/gems, etc.

PVA glue

art paper or wood panel

black waterproof pen, fine-point and foil glue pen

ERASER

white eraser

tracing paper and pencil

glitter glues in different colors

silver INK

gold/silver foils, paint or ink

paints and pens of your choice

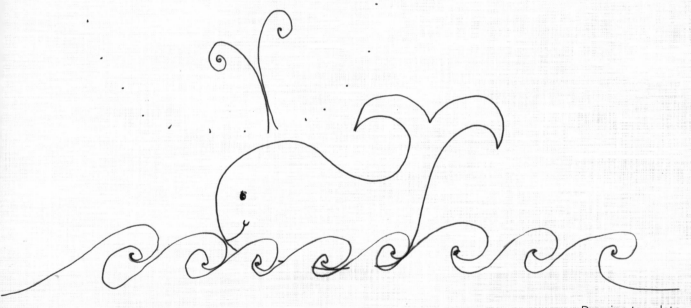

Drawing template

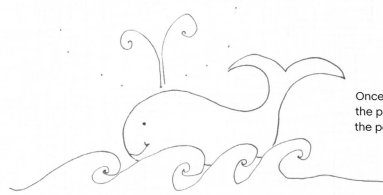

• 1 •

Once you have traced the whale template, go over the pencil tracing with a thin black pen, then erase the pencil markings. Now you're ready to start your Wishing Whale.

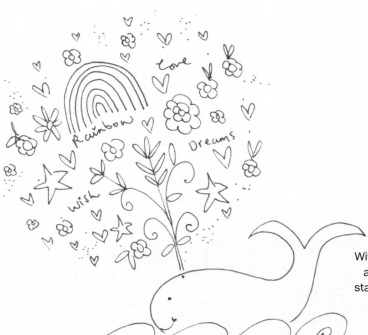

• 2 •

Within the circle of dots—your whale's "flower burst'" as I like to call it—you can start to doodle flowers, stars, hearts, a rainbow, and even a phrase or names and dates if you are personalizing it.

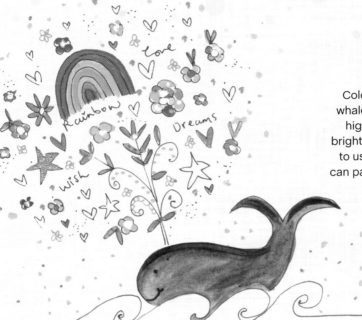

Color time! With this design I like to start with the whale and use blue watercolor paint, adding darker highlights to the tail and head area. You can use bright colors for your flower burst doodles, and I tend to use a mix of gel pens and paints for this bit. You can paint the sea but I love to do the whole sea in foil!

• 4 •

Optional

Add collage with punched-out flowers and stars and maybe some sequins and gems, too. If using the foiling technique, I like to add lots of dots above the foil sea and make the stars and hearts gold foil, too.

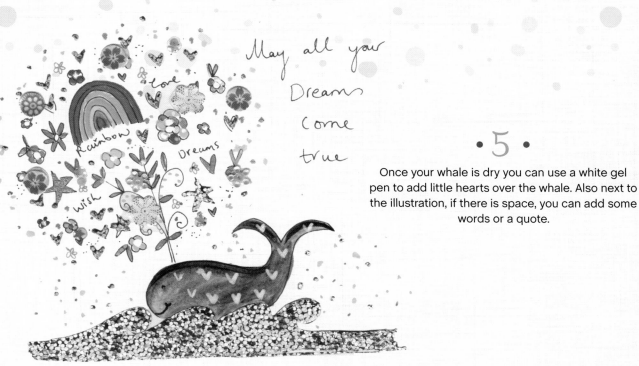

May all your Dreams Come true

• 5 •

Once your whale is dry you can use a white gel pen to add little hearts over the whale. Also next to the illustration, if there is space, you can add some words or a quote.

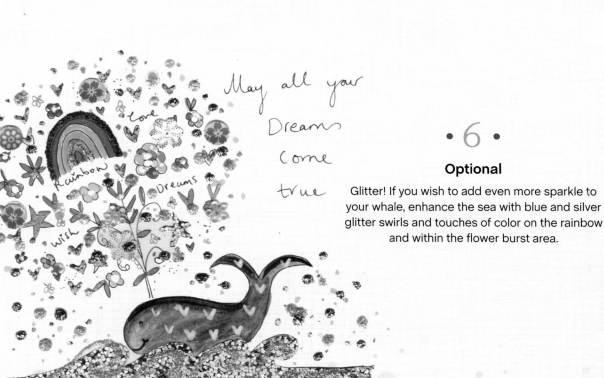

May all your Dreams Come true

• 6 •

Optional

Glitter! If you wish to add even more sparkle to your whale, enhance the sea with blue and silver glitter swirls and touches of color on the rainbow and within the flower burst area.

love

special

magic

dreams

May all your
dreams
come
true

SEA

Creating a Fanciful Mermaid

I created this mermaid as a personal challenge. I have never been very comfortable drawing people or faces. I surprised myself with her and was quite enchanted when she arrived on my paper. I hope you're enchanted with your own mermaid!

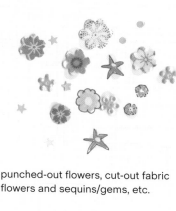

punched-out flowers, cut-out fabric flowers and sequins/gems, etc.

PVA glue

art paper or wood panel

black waterproof pen, fine-point and foil glue pen

white eraser

tracing paper and pencil

glitter glues in different colors

gold/silver foils, paint or ink

paints and pens of your choice

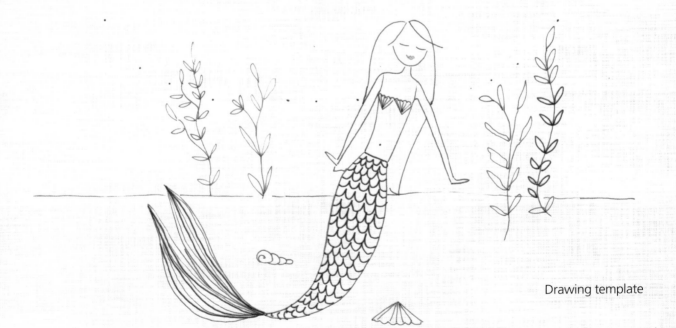

Drawing template

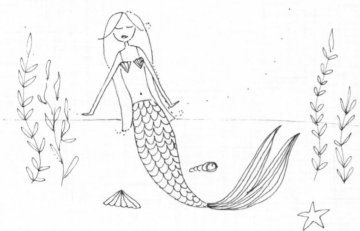

• 1 •

Place tracing paper over the mermaid design, then transfer and rub onto your chosen surface. Don't forget you can change the mermaid to your liking, such as giving her curly hair, a longer tail or put her in a different position.

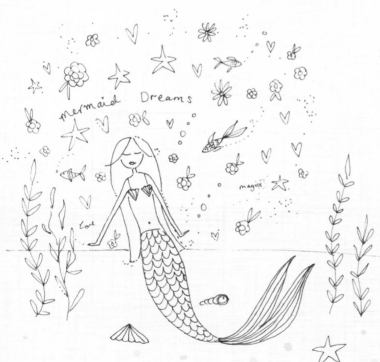

• 2 •

Once your mermaid outline is ready, go over the design with your black pen, then rub out the pencil lines. Within the dots surrounding her you can be "doodle free" and draw anything you like from fishes, flowers and stars to adding words, names or even a quote.

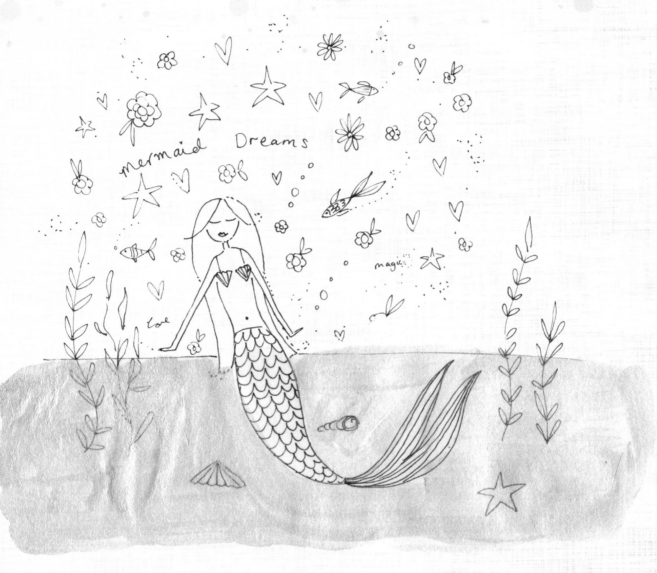

· 3 ·

For the sand I use a lovely wash of gold ink but you
could use a sand-colored pencil or paint, too. Or
maybe you would like to cover the sea bed in more
seaweed or rocks, the choice is yours!

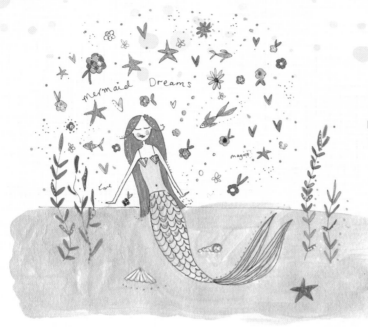

• 4 •

Now you can start to color in your illustration with your chosen medium and color palette. (More on color palettes in the next chapter!) I like to use greens and blues for this design.

***Top Tip**

Gold and silver gel pens are great for the fishes and the mermaid's hair.

• 5 •

Optional

Once colored in you can now choose to add foiling to your sea beauty! I especially love to make her tail extra sparkly with silver foil. Also at this stage feel free to use the collage technique and add some punched-out flowers or stars and maybe gems and a little extra one in the mermaid's hair.

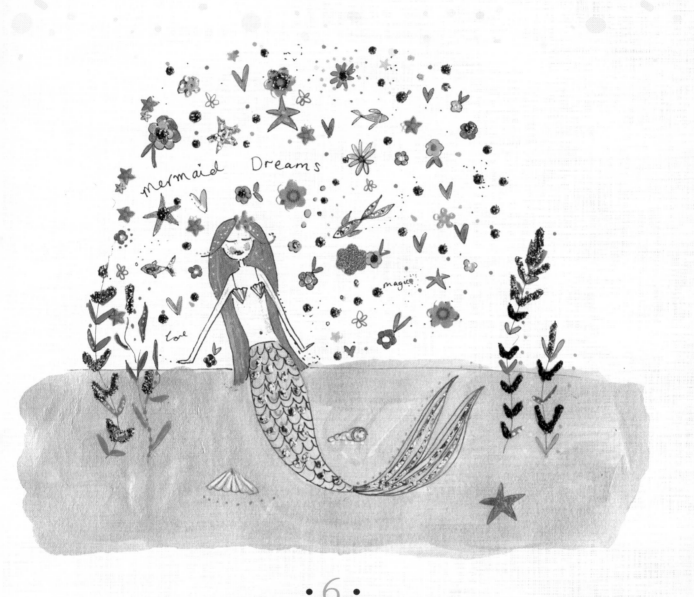

• 6 •

Optional

As always, if applying glitter it's best to do it last. I
like to add green glitter to the seaweed and some
blue and silver all over to highlight the water effect!

Creating a Rose Garden

This is a lovely mixed-media design using fabric and paper collage. Building up layers with paints, pens and collage gives the garden lots of depth. I have used roses in this design but you can try any type of flowers you like such as daisies or tulips.

art paper or wood panel

punched-out flowers, cut-out fabric flowers and sequins/gems, etc.

PVA glue

black waterproof pen, fine-point and foil glue pen

ERASER

white eraser

tracing paper and pencil

glitter glues in different colors

gold/silver foils, paint or ink

paints and pens of your choice

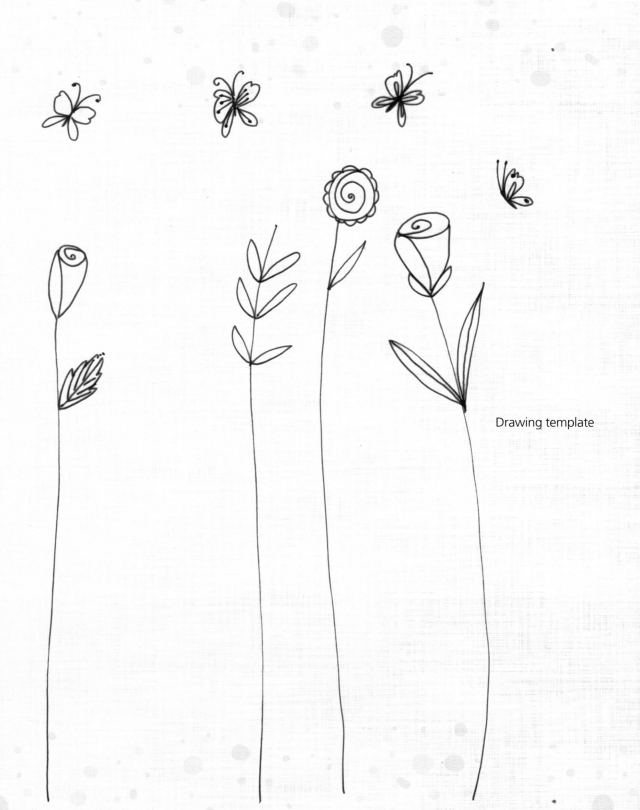

Drawing template

With a pen, trace the template, or freehand draw a few long stalks with some buds and also some simple butterflies.

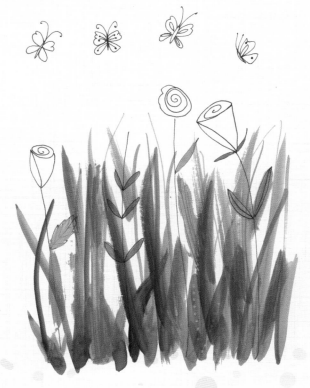

• 2 •

Using lots of different greens—paints and pens—start to build up layers of grass stalks and leaves. Be fairly loose with this and use a variety of thick and thin lines. There's no wrong way; just be carefree!

While your grass is drying, spend some time cutting out fabric flowers and punching out paper flowers. Cut out some leaves, too.

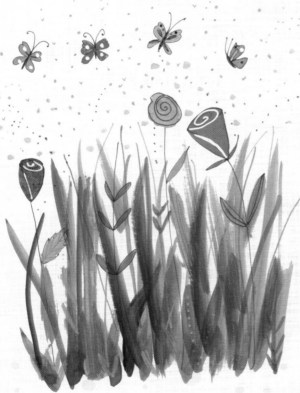

· 4 ·

Paint or color your drawn flowers and butterflies, and add lots of dots of color for the spray effect above your garden.

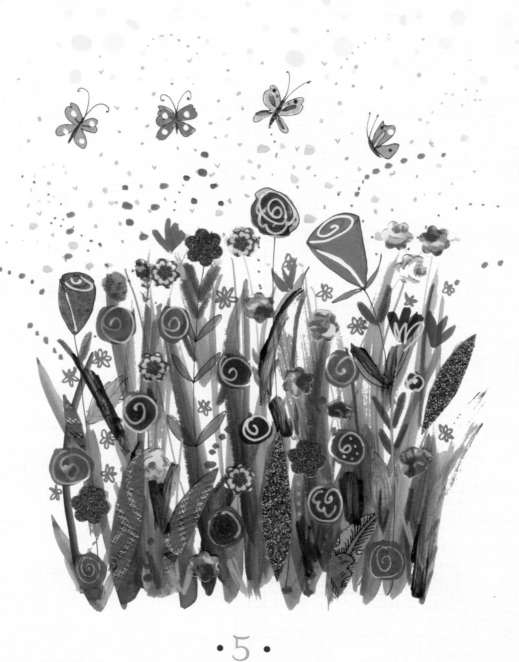

· 5 ·

Now glue your collage pieces onto the grass stalks
area. Build it up with added cut-out leaves and maybe
paint some additional flowers, too.

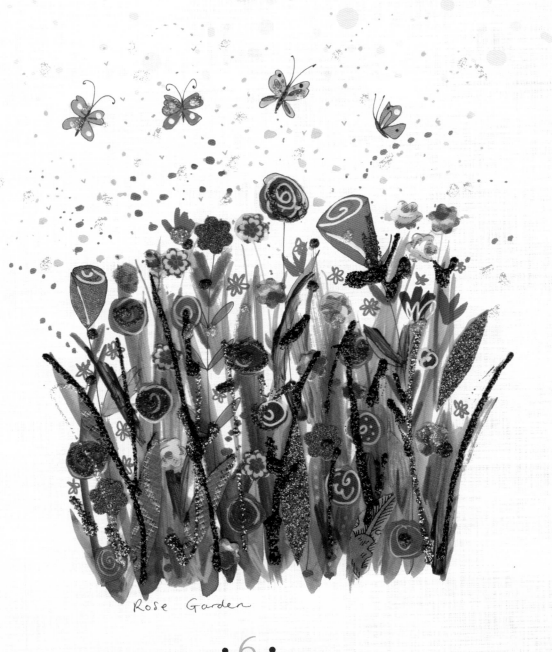

Rose Garden

· 6 ·

Optional

Have fun adding lots of green glitter to this design to
really enhance the grass. Also, you can highlight the
roses by dotting some red or pink glitter on them.

Creating a Butterfly in a Heart

I like to use the foil technique heavily on the butterfly, but you can always use paints or pens instead.

What You Need

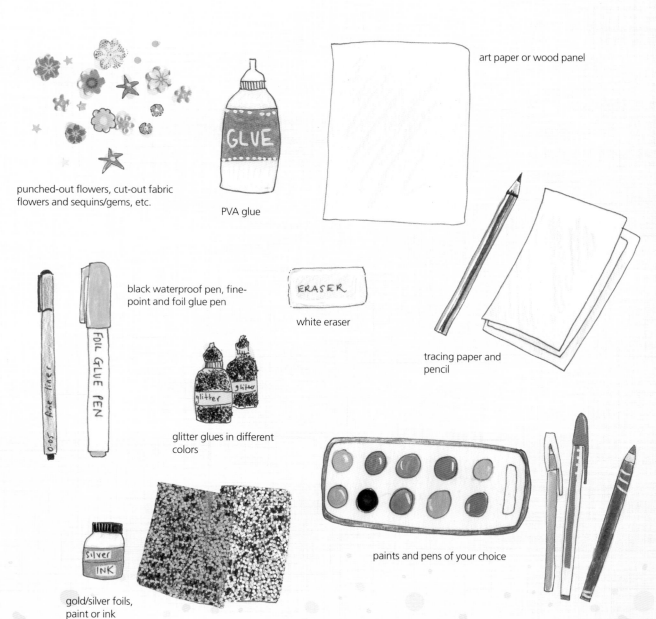

punched-out flowers, cut-out fabric flowers and sequins/gems, etc.

PVA glue

art paper or wood panel

black waterproof pen, fine-point and foil glue pen

white eraser

tracing paper and pencil

glitter glues in different colors

gold/silver foils, paint or ink

paints and pens of your choice

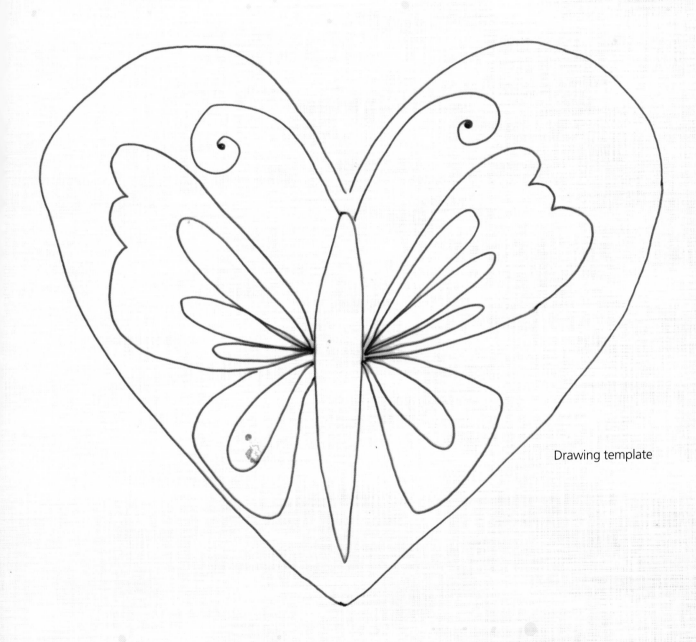

Drawing template

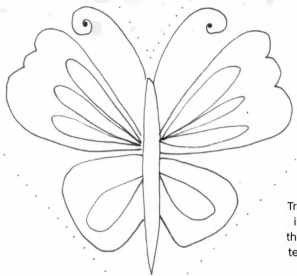

Trace the template, then go over the pencil outline in black pen, but be sure to just do little dots for the heart shape as a guideline for your doodle pattern. Again, feel free to design your own heart and butterfly shape.

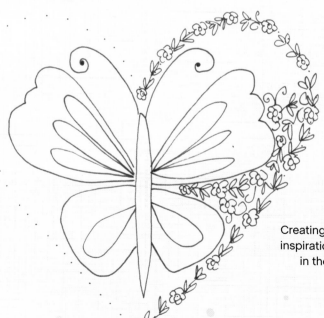

• 2 •

Creating your own doodle pattern, or using my mine as inspiration, carefully go around the heart outline and fill in the heart with doodles, avoiding the butterfly.

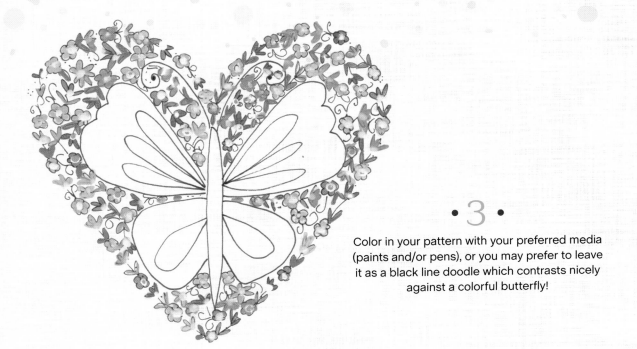

• 3 •

Color in your pattern with your preferred media (paints and/or pens), or you may prefer to leave it as a black line doodle which contrasts nicely against a colorful butterfly!

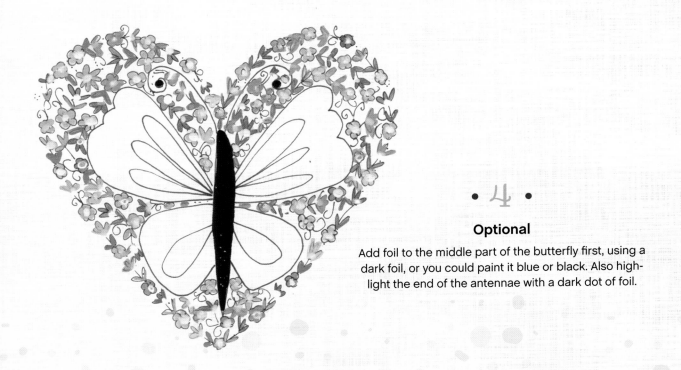

• 4 •

Optional

Add foil to the middle part of the butterfly first, using a dark foil, or you could paint it blue or black. Also highlight the end of the antennae with a dark dot of foil.

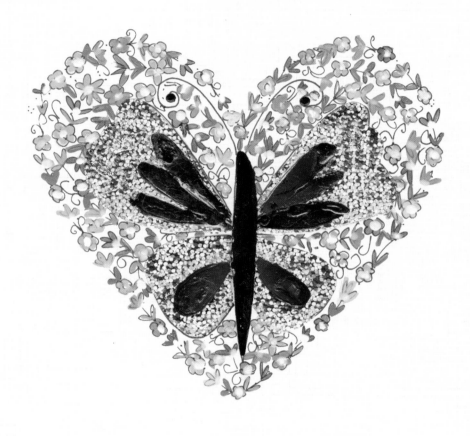

• 5 •

Optional

Add foil or color the sections of the butterfly. You can create whatever pattern you like. As my doodle pattern around the butterfly is quite intricate, I like to keep my butterfly fairly simple and bold.

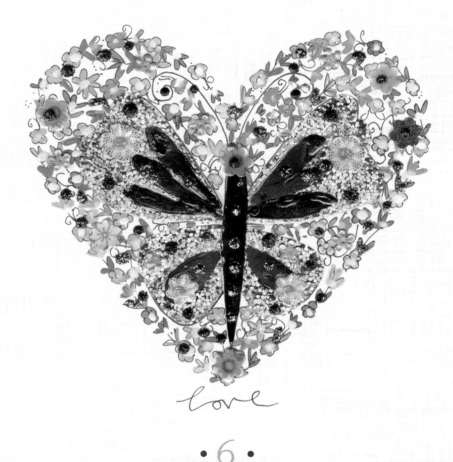

love

• 6 •

Optional

Add dots of glitter to the butterfly and heart pattern;
also try a punched-out flower shape for the head. You
can add words at the base or maybe all around the
shape of the heart. Personalization is lovely for this
design, especially if it's a gift.

 # Creating a Flower Burst Teacup

For this wonderful design, you can really build up the layers for lots of texture using collage. This floral teacup is bursting with joy!

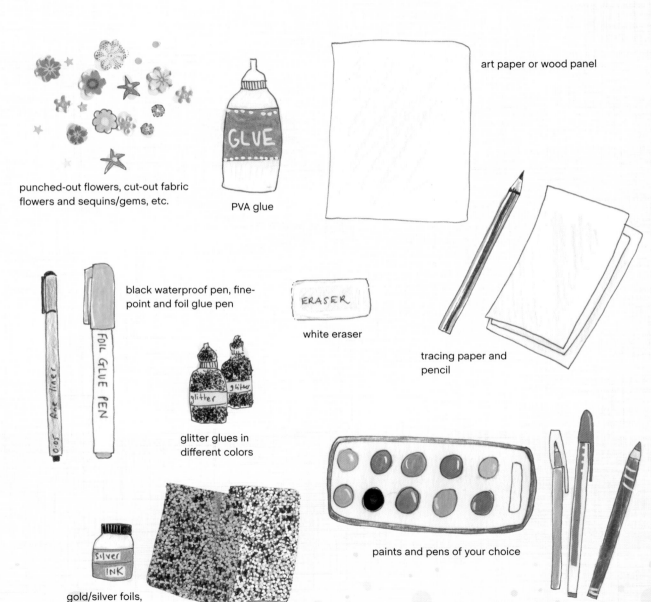

punched-out flowers, cut-out fabric flowers and sequins/gems, etc.

PVA glue

art paper or wood panel

black waterproof pen, fine-point and foil glue pen

white eraser

tracing paper and pencil

glitter glues in different colors

gold/silver foils, paint or ink

paints and pens of your choice

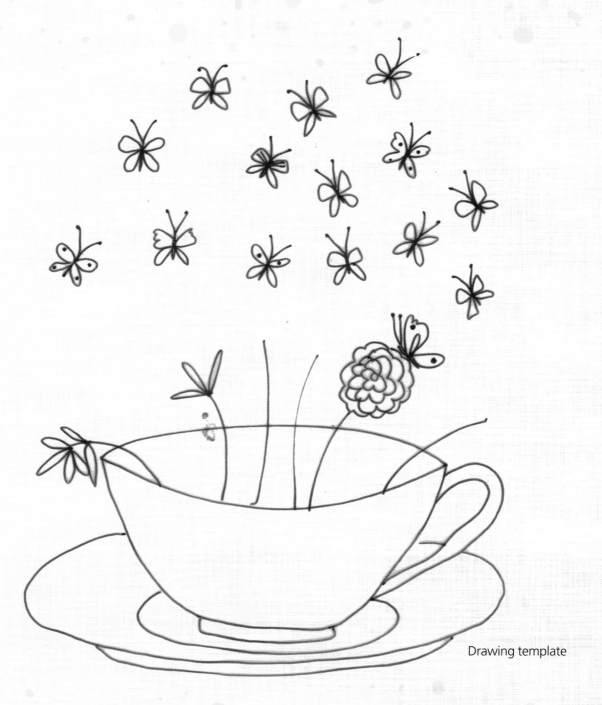

Drawing template

• 1 •

Trace the template (or freehand draw your own cup and saucer), with just a few flower stalks poking out of the cup.

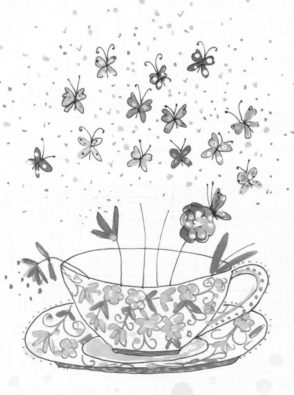

• 2 •

Paint or color in the butterflies with pens/pencils and design the cup and saucer with a pattern you like. (Have a look at some magazines for inspiration or even in your kitchen!) This is a great design for Mother's Day if you want to personalize it.

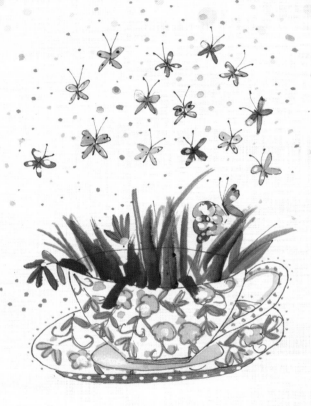

• 3 •

Start to loosely draw and paint on some green stalks and leaves to fill the cup.

• 4 •

Punch out lots of paper flowers and cut out some fabric flowers and leaves, too, for added texture. You can also use gems and sequins.

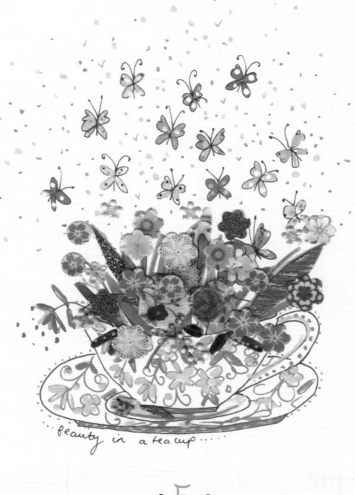

beauty in a teacup

• 5 •

Now glue on the flowers and leaves so it looks like
they are really bursting out of the cup. The more
flowers the better!

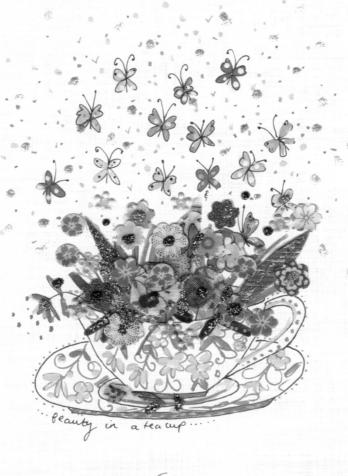

beauty in a teacup

· 6 ·

Highlight your designs with sparkle! Glitter glue is
great for this, especially on the leaves and above
the flowers.

Creating a Birdcage

This is one of my favorite designs; I love that the cage door is left open. Using a mix of collage, paint and fine line art you can also create this beautiful and delicate design. Try drawing your own style of birds or even change the birdcage shape.

What You Need

punched-out flowers, cut-out fabric flowers and sequins/gems, etc.

PVA glue

art paper or wood panel

black waterproof pen, fine-point and foil glue pen

white eraser

tracing paper and pencil

glitter glues in different colors

gold/silver foils, paint or ink

paints and pens of your choice

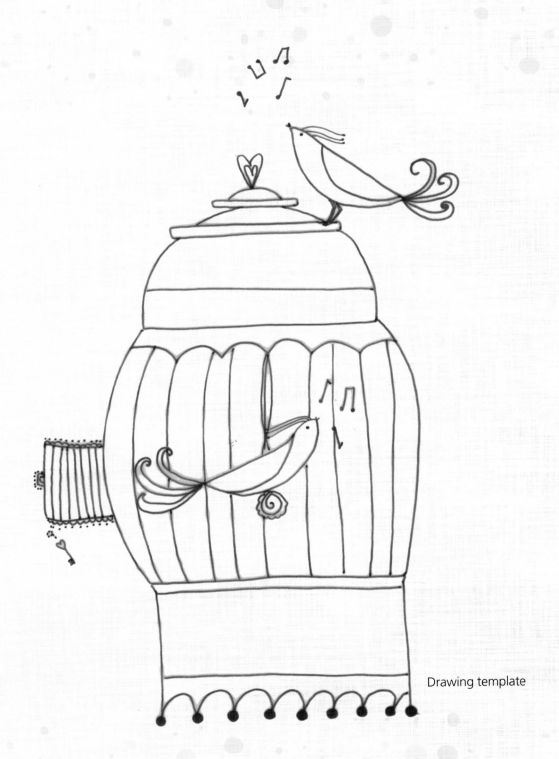

Drawing template

87

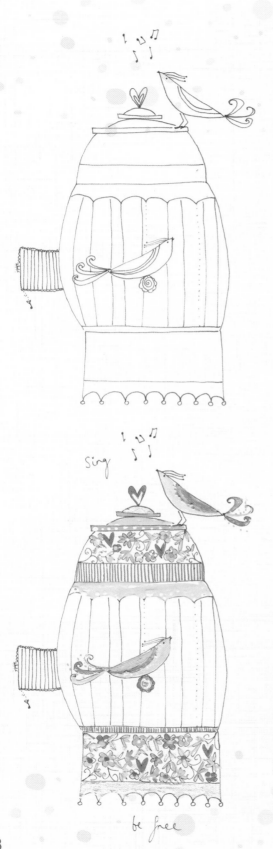

sing

be free

Begin by tracing the template or drawing your own design. Because this is an intricate illustration, try using a fine pen to get the most detail.

Add a doodle pattern in the top and bottom parts of your birdcage, then start to color in your design. I love to use blues and lilacs on the birds but with some soft touches of gold ink, too, in and around the birds and cage. You can also add some inspirational words!

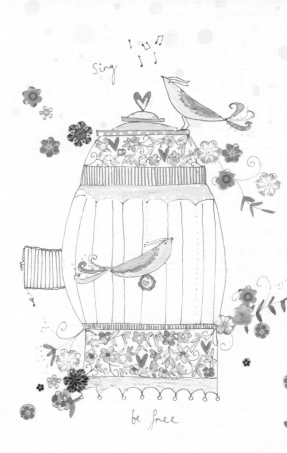

• 3 •

Start to create some trailing flowers and leaves around your birdcage. You can draw or collage this part or use both like I have.

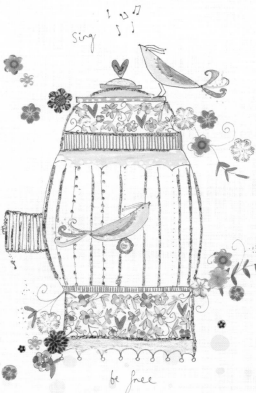

• 4 •

Add some foil to the design, if you like, mainly on the cage itself to give it a metallic effect.

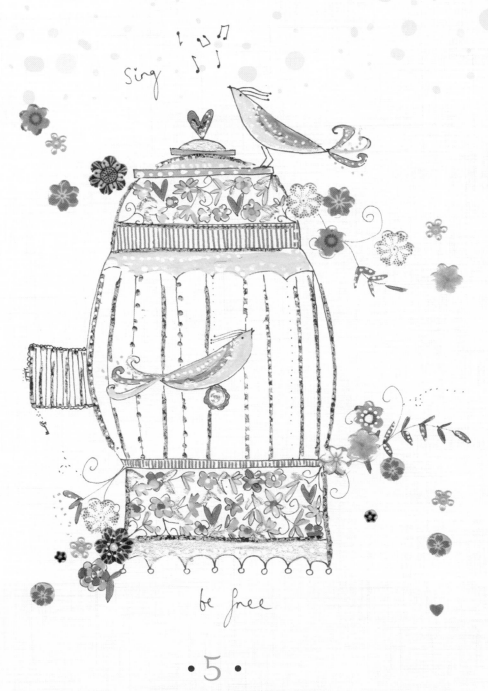

sing

be free

• 5 •

Use a white gel pen to add tiny little dots on the birds
and over the foil cage, too. This gives the design an
intricate feeling. This technique has become a habit for
me with most of my designs.

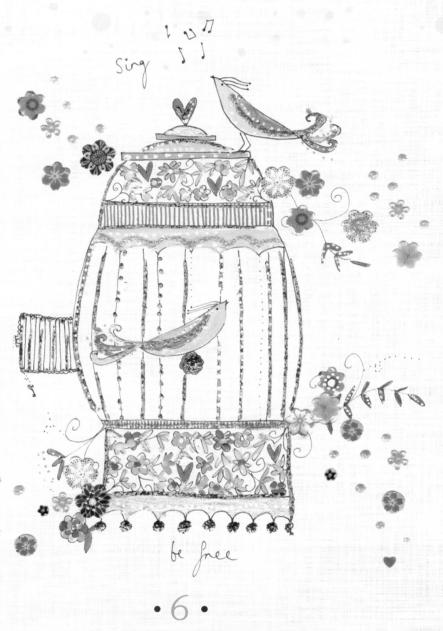

sing

be free

• 6 •

You can bring your birds to life a bit more by adding some glitter to them. This gives them almost a three-dimensional effect on their wings. I like to put some dots of silver or gold glitter on the base of the cage, too.

Creating a Magical Unicorn

I adore this design! It recently became published as a cross-stitch design, too! It's sparkly and dreamy and who doesn't just love a magical unicorn, encouraging you to follow your dreams?

What You Need

punched-out flowers, cut-out fabric flowers and sequins/gems, etc.

PVA glue

art paper or wood panel

tracing paper and pencil

black waterproof pen, fine-point and foil glue pen

ERASER

white eraser

glitter glues in different colors

paints and pens of your choice

gold/silver foils, paint or ink

92

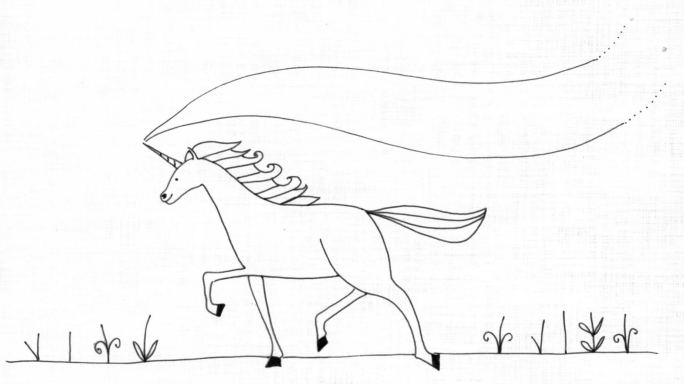

Drawing template

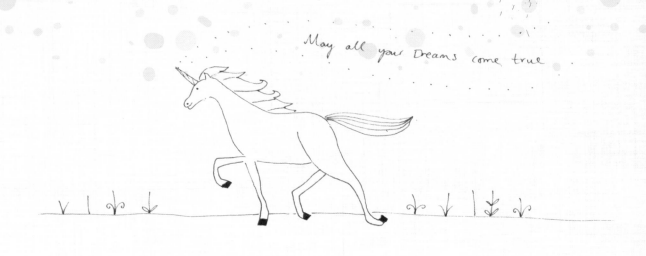

May all your Dreams come true

• 1 •

Trace the template. Make little dots as a guideline for
the magical stream that will flow from the unicorn's horn.
Also add some words or personalize with names or
dates, or even a lovely quote!

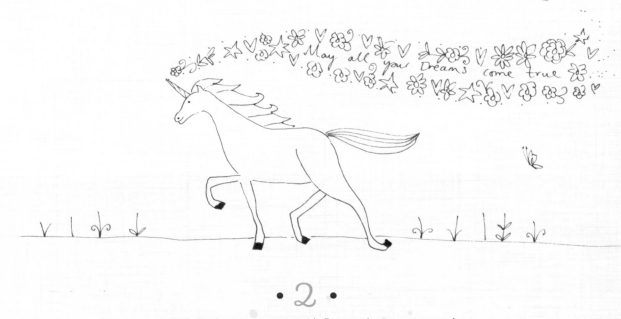

May all your Dreams come true

• 2 •

Doodle in the stream area with flowers, hearts, stars and
maybe even a rainbow and some butterflies.

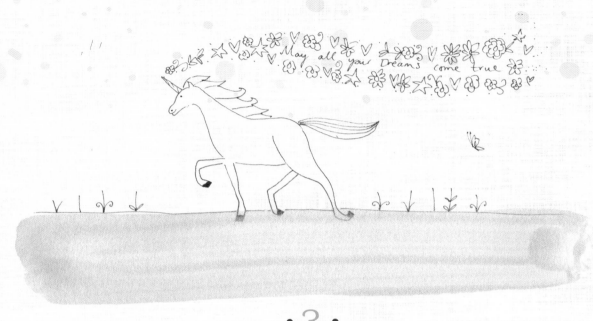

• 3 •

Add a wash of gold ink for the grass area. You could also
paint or draw grass. If you wish, your unicorn can fly if
you add some wings and a blue sky!

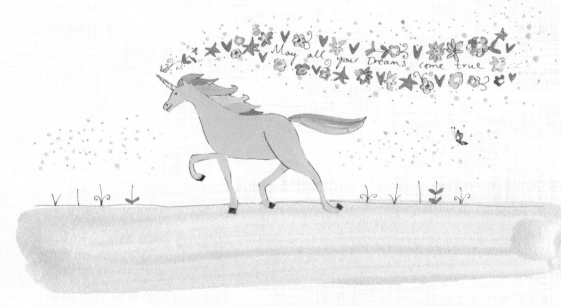

• 4 •

Color in your design with lots of dots for a magic "spray"
effect around the flowers and around the stream.

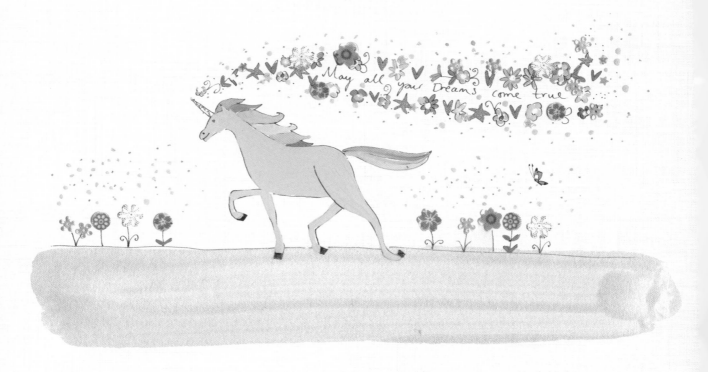

May all your Dreams come true

• 5 •

Punch out some flowers and attach to the top of your
stalks and also add some flowers to the unicorn's
stream with the addition of sparkly sequins, stars and
gems if you like. The more magical elements the better!

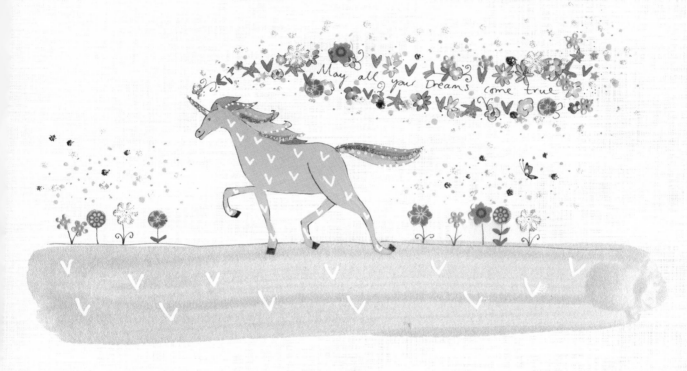

May all your Dreams come true

· 6 ·

Using your white gel pen, draw some little hearts on the grass and on the unicorn; these little extras can really be a great finishing touch to your design. For the unicorn's horn, I like to use a little dab of sparkly glitter!

Trying Out New Surfaces

Painted Pebbles

I just love to work on different types of surfaces, such as paper, canvas and wood. The techniques I've shown you work well on all of these so give them a go sometime!

My latest surface has been the beautiful, simple pebble. I really did stumble across doing this after a trip abroad. I had brought back a couple of souvenir pebbles from a beach and they sat on my desk for a while until one day I was compelled to add one of my sparkly foil hearts to one and then paint the other one. I was hooked! The mixture of the pebble's natural beauty with the addition of foil and paint just seemed to make the stone so special. The response has been was amazing, and they have been selling like hot cakes (or should that be hot rocks)!

They make wonderful gifts, home décor accents or paperweights and they feel lovely in your hand to just hold as well as look at.

I'm really happy to share with you my latest inspirational art and hope you can also come up with your own unique designs for your pebbles.

What You Need

pebbles

brushes

acrylic paint

matte varnish and brush

foil glue pen

foil and gold leaf

black pen

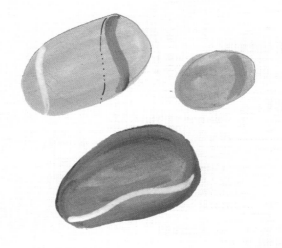

• 1 •

Wash your pebbles and let them dry thoroughly.

• 2 •

With your chosen color, paint one side of the pebble and set aside to dry. Repeat on the other side. You might need to do two coats. (I sometimes set my pebbles on the radiator to help them dry more quickly!)

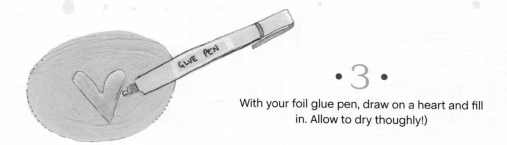

· 3 ·

With your foil glue pen, draw on a heart and fill
in. Allow to dry thoughly!)

· 4 ·

Add your foil or gold leaf. A simple word may be
added using a paint pen or permanent marker.
Or, if you're comfortable, you could paint the
word on using a fine liner brush.

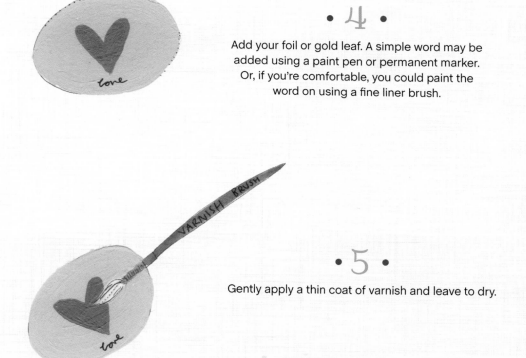

· 5 ·

Gently apply a thin coat of varnish and leave to dry.

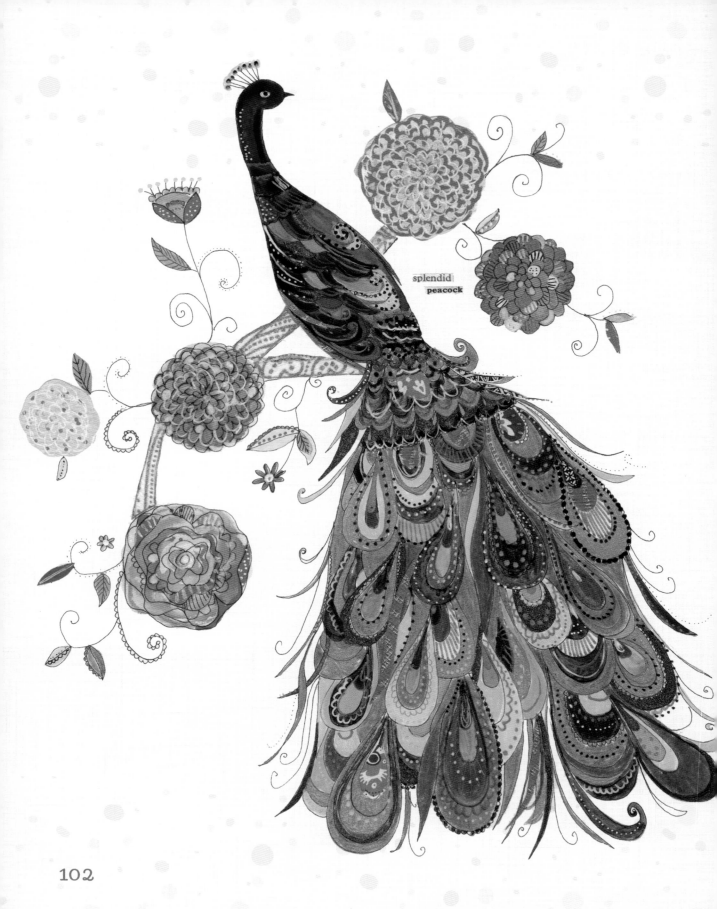

splendid
peacock

3

Bloom
(Discovering Your Own Style)

I have always loved this quote by Pablo Picasso. It speaks such truth and after all, inspiration is a very fundamental part of our creativeness. We need to be inspired to create, but unless we create from our inspirations there is nothing to see. You have to show up and do the work, too.

We all have days when we don't feel inspired at all, but inspiration really is all around us: people, nature, animals, other countries and cultures, artists, music, words, memories, magazines, vintage and contemporary designs; even just our art materials can be inspiring with the colors and textures they create. It is through what we personally find inspiring that we can develop our own art style. As we are all inspired by different things, this will help your unique style to bloom. But like the quote says, we do have to show up and work.

Inspiration exists,
but it has to find you
working.

—Pablo Picasso

Whatever part of your art journey you are on, whether you are a full-time artist in your studio every day or a part-time artist who indulges once a week at the kitchen table or someone who only creates sitting in bed when all is tranquil with a sketch pad, insist on creating regularly. Sit with a sketchbook or blank canvas in front of you and sketch something that comes from a tiny idea you have thought about for ages. Enjoy being creative and watching your creation come to life rather than remaining a thought or image just in your head.

It is from these moments that our ideas and inspirations can really grow and unfold, and that little seed we planted is now flourishing with excitement. Suddenly we realize we have too many ideas we want to try. I often wake up in the middle of the night and have to jot down an idea or design in my sketch book (always one by my bed!). But often these moments of creative excitement seem great in my head, then do not always work as well on paper. This can lead to disappointment and within seconds my creative passion is dampened. What I have learned from this is that I do actually need to push my boundaries from time to time and leave my comfort zone. I really like my comfort zone of doodling and creating my trees, which I can do every day quite happily. But when I get new ideas and they don't transfer like I want them to, I know I have to do "the work!" The challenge can be fun and the rewards great. So as much as a lot of my art is created from the ease of what's familiar, I have also had designs that pushed me further in the areas of research, sketches, color, etc. Two examples are my peacock and birdcage designs. These two designs were not as simple to create but now that I have created them, I can redo them with ease and fun just as I do my other designs, and in hindsight I am so glad I did the extra hard work. (Plus, they have since been published as greeting cards, licensed wall art, home décor and cross-stitch kits. I am as proud as my peacock!)

What I love about discovering our art style or developing our existing style is that it always comes back into balance again. Have fun with your art. Find inspiration and play, but occasionally just push yourself a bit, or try something new and see where it takes you. This combination will really help you find and fortify your true and authentic art style.

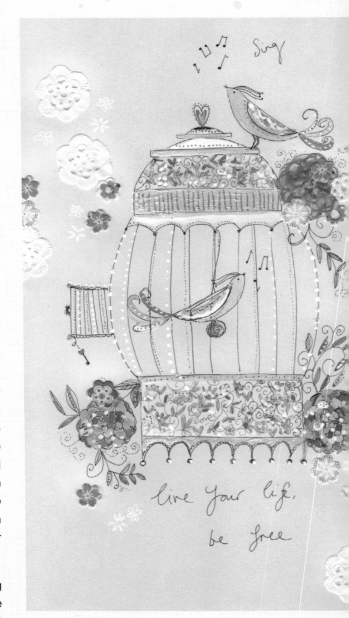

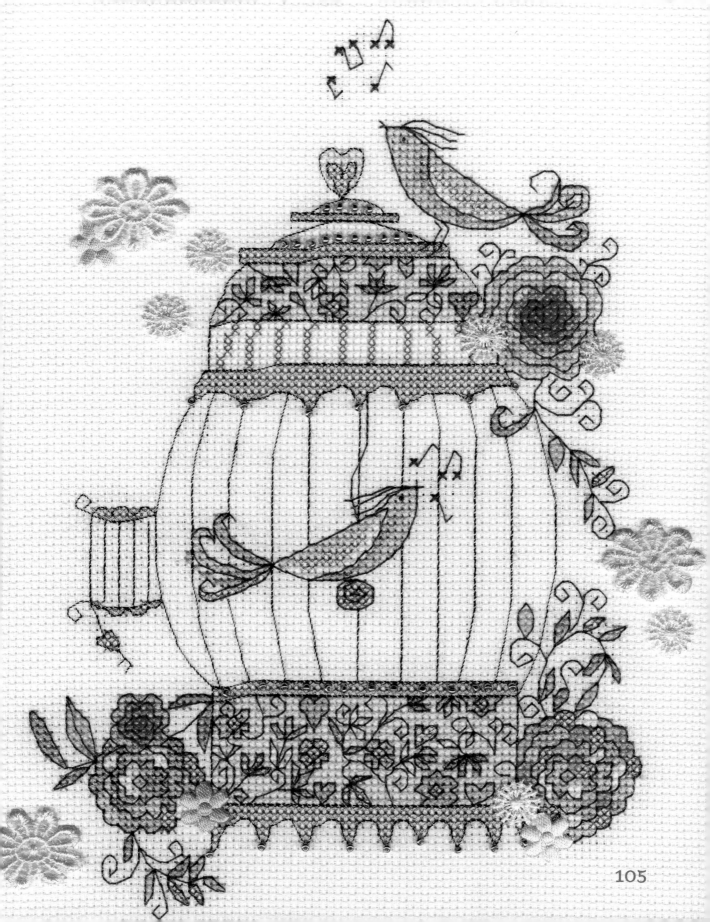

Figuring Out What You Want

An Exercise to Help You Bloom

Sometimes we all need a little direction with our art. As much as inspiration plays a big part in our creativeness, we can also benefit a great deal from some form of direction, which can really help our art bloom even further. Direction can also help us figure out what we want from our art and the places it could take us.

When creating commissioned artwork, I would sometimes have to work to the direction of a brief that would assign me a color palette and occasionally a theme or style. For example, a new baby girl tree in pinks and boy tree in blues. Or creating a greeting card range, using mainly cut-out text, bright colors and simple line art.

Working to assigned briefs such as these require lots of research time and sketching, and it can be easy to wander off the path. You have to sometimes pull yourself back, but this is all part of the nature of being a working artist—occasionally disciplining yourself within your art as you spread your wings. Of course, being free and going with the flow in your art is a must, but it does us no harm now and then to follow some guidelines and rules. Balance is good for us and our creativeness.

I hope with the following exercise/brief you will spread your wings but also be excited about what you might create and the direction it may take you!

Exercise

We're going to create a surface pattern design (all-over art) using mixed media and some techniques we've already explored. And, we're going to create this design according to the following directive brief.

Brief

Imagine a magical under-the-sea world with fishes, mermaids, seaweed, turtles, corals, sharks, pebbles, rocks, sunken shipwrecks and lost treasure chests. Perhaps you see turtles, jellyfish, eels, octopi and crabs? I'm sure you can think of other elements, too!

Using the color palette, you can design this on paper or canvas with pens, paints, decorative paper/fabric collage, glitter and foils. (Foiling on the fishes and a mermaid's tail would be magical!) Try sparkly gems for treasure and paper collage for bright orange starfish! Although you are working to a brief, experiment with your materials.

Your design can be intricate, have bold lines or be sketchy, have repeated doodles or be really simple with just a few elements surrounded by the water.

Think about adding text, poems and quotes about the sea. You could use letter stamps, swirly handwriting or cut-out letters.

Do you feel excited about starting this design? I do! Ideas are coming to me as I write this brief! I'm already imagining the design as a shower curtain, wallpaper, giftwrap or on textiles and ceramics. It's good to feel excited about starting a new piece of art, especially when the direction for it has come from someone else, as this makes it new and fresh for you but will still be your interpretation. Every artist's piece will be unique but with the same theme and color palette.

Under-the-Sea Color Palette

> * I love to purchase paint tester pots as they come in a wonderful array of shades and colors! They're perfect for creating a palette in similar tones.

Here are some more exercise prompts for you to try. You can mix and match the color palettes with the themes or even have a go yourself at creating a brief!

Dreamy Pastels Palette
Think fairies, princesses and magical unicorns. I love to use soft pastels to create dreamy trees, too.

Brights Palette
Rainbows, hearts and beautiful flowers are perfect for this palette.

Vintage Palette
Look to beautiful Victorian botanical florals for inspiration; these colors works wonderfully! Create romantic floral patterns—roses especially—in vintage pinks.

Autumn Greens/Golds Palette
Try some nature-style doodles with leaves of all different shapes or maybe an autumn-style tree with some country animals such as squirrels, foxes and hedgehogs.

Letting Go

Now that you've had a chance to develop your skills and let a style of your own emerge, I'd like to suggest you stop thinking about your style for a minute and give yourself a break.

Once a month or so I feel a huge urge to be very free and go a little wild with my art. It's almost like I need to get it out of my system, then I continue on my creative journey with the art I love to do everyday. It's a bit like when you've been on a health kick and you need to indulge in takeout or big bar of chocolate. It almost helps you keep on that path, otherwise the pull of what you want or need can take over so much that you completely "lose it" altogether!

So this crazy art I love and need to do occasionally is not the kind of art that sells like my other pieces, but every now and then I can create a piece that is appealing and actually sells. I don't start these pieces thinking they will be on my art page for everyone to see; they are purely for me and my experimental creative freedom. These are usually on canvas—some big, some small—and I will often go over the same canvas again and again, especially the large canvases that I really love to work on. I adore using every bit of mixed media I have in my studio: collage papers, paints, metal leaf, foil, spray paints and embellishments. I have even applied resin to some of these pieces, which was great fun and experimental, too. There are basically no limits!

Now you may be asking why I don't create this work all the time if I love to do it. In most of my designs I am quite intricate and I do like to work quite neatly and organized. I know I couldn't work messy and wild all the time, and I really only need the odd opportunity to unleash, then I'm quite happy and ready to get back to my tidiness and organized working routine again. So, again, it comes down to balance. In order to produce the illustrations, pebbles and painted wood pieces that I love so much, I really need to let loose occasionally to keep me in balance with my everyday creative life.

Have a go yourself at a "letting go" art day! (Or maybe you do already, which is great!) I think it's so therapeutic and essential to our creativity. Try working on a canvas or even let loose on an old wooden chair or piece of furniture! I have often painted an old chair and come back to it time and time again by adding something different each time. Get messy and carefree with your canvas; don't worry about making it look pretty, just let go and trust your intuition. Make marks, collage, scrape back the paint, spray paint, draw and experiment with the techniques we have already used, such as applying foil and glitter, but maybe try it other ways such as adding lots of glitter and cutting out the foil sheets and gluing on the canvas in random ways. This is the time to experiment and have fun!

May all your

DREAMS

Come

True

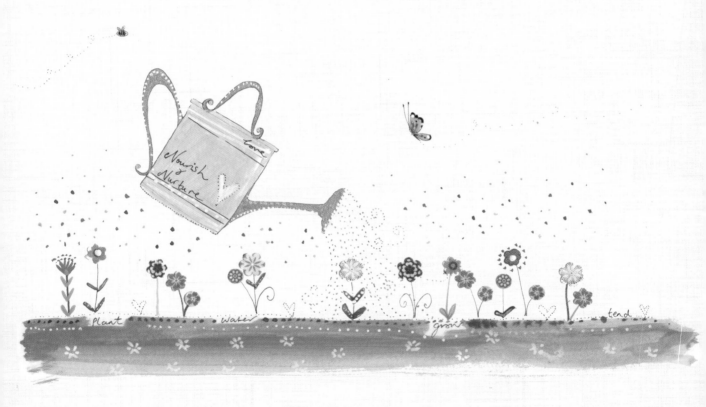

Grow and Tend (Try New Things)

I currently hold close to my heart the words *grow* and *tend*, and I feel that's exactly where I am on my own creative journey—nurturing my art and yet still growing.

You may be starting out or thinking about planting your own creative seeds, or maybe you have already bloomed with your art and are well on your way to living your own creative life. Either way, the important thing to remember is we all began at the same place. It's how we continue to grow and nurture our creative practice that tells the rest of our art stories.

Unless you try to do something beyond what you have already mastered, you will never grow.
—Ralph Waldo Emerson

Are you grateful for the journey you've been on so far? The very word *gratitude* has so much more meaning to me these last few years. When you have people who start to buy your work or give you lovely comments about your art, you feel a huge sense of gratitude, mainly because you are doing something you love to do. So when someone wants to buy your work or maybe commission you, it's a natural feeling to be very thankful. It can be quite overwhelming when you sell your first piece of art. It's almost surreal that someone wants to buy what you have actually made. But enjoy it and start to believe in yourself. We must also remember, it's not just the art people buy into, it's also the person behind it, her story and her personality. In today's world, social media makes it easy to get such a glimpse.

You may not realize how your art has inspired someone, helped him/her or moved him/her in some way. That's magical! But the true magic comes from you as a person showing your gratitude and kindness. This combined with your creativeness is a magic potion that can make your creative dreams come true.

Occasionally, it's good to add other ingredients into the magic potion, such as a sprinkling of bravery! This could be something simple and not too scary, maybe working with a different medium or in a size you don't typically work in. Or maybe just a bit braver such as sending out images of your artwork to licensing companies or an art gallery.

The reason I use the word *brave* is because sometimes when we try something new, we are open to negative feedback and rejection, which is not a great feeling. However, it's important to realize that not everyone will like you trying something new or your art may just not fit in with that particular greeting card publisher or gallery. But . . . there's also just as much chance that something wonderful could happen and new doors could open!

About three years ago, I saw a fellow artist with her design on a cross-stitch kit. I had never thought about my art used in this manner, so I thought, why not try? I emailed the company and they took two of my designs, which have since become their best sellers and my collection is growing with them. There are lots of companies out there who license art on just about anything, so it's worth researching on the Web and emailing companies with your art images. It's also through this process you can discover something new that you hadn't thought of before. Another idea is to email blog owners and ask to be featured or even start up your own blog. Start today and try something new!

When inspiration has come to me, such as for my doodle trees, sparkle pebbles and, more recently, my foxes and Northern Lights paintings, I have always noticed it's been when I am relaxed, happy and with loved ones. Inspiration is not always about "looking for it." Sometimes trying to force something to appear only results in frustration. Let it come to you naturally, and it will appear at the right time!

Take time out and go somewhere new, have time with your loved ones, talk and see new things—just enjoy being.

The Northern Lights have always been a fascination of mine and it's a dream of mine to see them one day. Of course, this would be considered visual inspiration and I have always had it in my head to incorporate them into my artwork somehow, but I didn't rush it; it just happened when the time was right for me.

Trying Courage on for Size

An Exercise for Sneaking in Brave New Things

Do you ever wonder how some artists, designers and illustrators got their lucky break?

Whether it's a fabric line, published greeting cards, home décor products or illustrations for a book, there are so many products that require an illustration or painting. We also love to have actual pictures and paintings on our walls along with handmade crafts scattered around our homes.

It really makes you open your eyes and look around to what could be possible for you and your art or craft. What you're making in your studio, at your kitchen table or in your shed today could possibly be in a gallery, shop or part of a successful online business one day; you just never know!

But you do have to be BRAVE and put yourself out there (and put the hard work in). It can be daunting, but so exciting, too!

So, what's the brave new thing you could try to get yourself out there? I know many of you will be on different paths along your creative journey, so on the next page I have listed a variety of ideas to try that might suit you.

Brave Things to Try

- Start putting your art on social media.
- Attend an art or craft retreat.
- Sign up for an online art course.
- Open up an online art shop.
- Submit your work to companies, such as greeting card publishers, home décor, fabric, book publishers, etc.
- Commit to one day a week just for you and your art
- Join an online art group.
- Plan to do a stall at a craft fair or local market.
- Make a special art space for you in your home to create.
- Fill a sketchbook with doodles and ideas.
- Try creating with a new medium, such as oil paint, making something in clay or with fabric.
- Make a gift for someone and give it to her for no reason at all.
- Create your own affirmations and repeat them daily. (Example: I love my creative space or I am so happy my art brings joy to myself and others.)
- Write down your creative dreams and tuck what you've written away somewhere. Look at it from time to time, maybe adding more to it. Be brave and write what you truly dream of, no matter how big it is. It could be "My creative dream is to be an illustrator for a children's book." Or "I would love to have my art exhibited in a gallery." Or, perhaps, "I dream of being an art teacher."

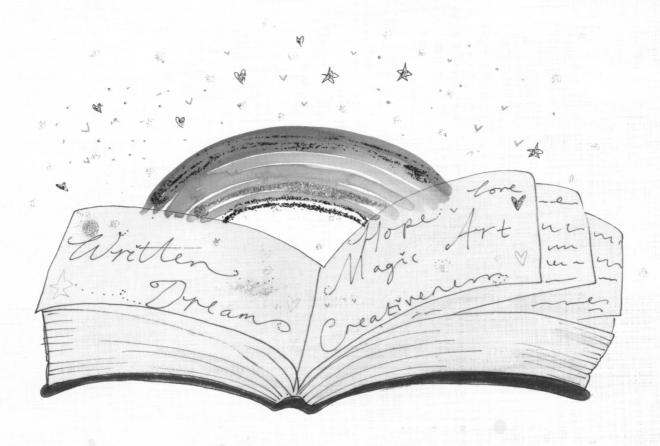

The Importance of Self-Care

I love the feeling of the words *self-care*. I feel they've been whispering in my ear this last year like a little magic fairy. I believe we all hear it but also feel guilty if we even dare stop and listen, so we just push on and occasionally end up burning ourselves out or getting creatively frustrated.

The reason I now love these words is because I recognize when I need self-care and most of all, I believe I can give myself permission practice it. I can see the benefits within myself, my family and my artwork. Stepping back from your artwork can sometimes be difficult but essential in order to once again see it with fresh eyes and feel revitalized mentally and physically to carry on.

So what does self-care really imply? It's looking after YOU and listening to your body and mind and getting in tune with what it needs to help you work, create, enjoy your home life and feel good!

When you feel run down, burnt out or creatively out of ideas, give yourself some time for you, away from your work.

Your self-care time could be a massage, yoga, a movie marathon, a nap, a hot bubbly bath (with a nice glass of wine), meditation, cooking, running or even a wardrobe sort out. As long as it's something for you. I tend to find watching a film or an early night in bed with fresh linen exactly what I need to relax and switch off. If you need a nap in the middle of the day, go ahead; listen to your body and follow what it wants. You're not being selfish, you're caring for yourself. You will find that you feel energized and refreshed.

I know it's not always possible to have these moments to ourselves due to family life and work commitments but what I'd like to stress to you is that when you do have time to yourself, make it for you and only you.

Even daydreaming is a good source of switch-off time and allows our minds to breathe and creative ideas to flow naturally.

I love just sitting and thinking. Some of my best artwork has come from pure thoughts, and most of this book has derived from thinking and thinking, playing around with ideas and words in my head. Not everything creative can be rushed from head to pen to paper. It sometimes takes time, just like on the flip side, some things can be instant. Once again it comes back to balance. We just have to listen, follow the flow and trust it.

Rest and self-care are so important. When you take time to replenish your spirit, it allows you to serve others from the overflow. You cannot serve from an empty vessel.

—Eleanor Brownn

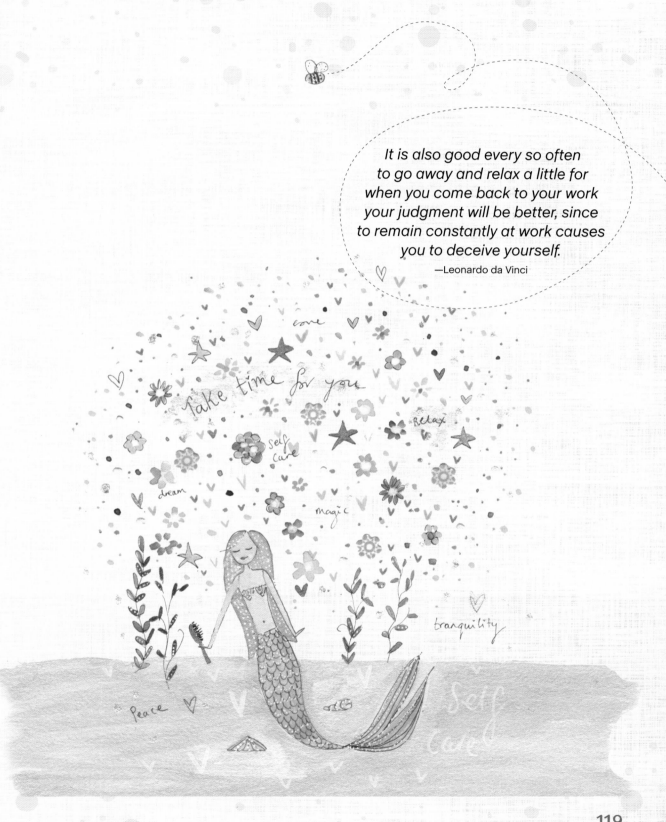

It is also good every so often to go away and relax a little for when you come back to your work your judgment will be better, since to remain constantly at work causes you to deceive yourself.

—Leonardo da Vinci

Finding Inspiration

Health, family, a little magic potion of love

When inspiration has come to me, such as my doodle trees or more recently my sparkle pebbles, I have noticed it's been when I am relaxed, happy and with loved ones.

Inspiration is not about "looking for it," because that is more along the lines of forcing something to appear and that's not how it works.

Instead, take time out and go somewhere new, have time with your loved ones, talk and see new things and just enjoy *being*.

Stress, anxiety and unhappiness make it a struggle to concentrate on work, a hobby and family life. And sometimes we just can't help but feel sluggish or run down. I find when I have days like this—and I'm sure we all do!—I personally cannot create at all. I find the best remedy is to go out in the fresh air, reflect, be grateful for what's around us and start fresh. Maybe a big bowl of wholesome soup, too, if you have been feeling run down.

Feeling loved, happy, healthy, content and with the ones we love or make us laugh, can be just the magic potion you need to be creative and for inspiration to appear, sometimes unexpectedly!

Love is the bridge between you and everything.

—Rumi

Some ideas for love, fun and health

Yoga

Soup making

Long walks

More hugs (for loved ones and your pets!)

Meditation

Listen to more music

Laugh (watch more comedies)

Make a family joint piece of art (maybe a large canvas
to paint on or large paper to collage on)

Drink herbal teas (my favorite is Moroccan Mint)

Blending Your Art with Another's

Artistic collaboration has been happening for centuries, particularly during the arts and crafts movement in the nineteenth century. One of my favorite designers, William Morris, founded a company with many other designers skilled in metalwork, textiles, carpentry, wallpaper and jewelry. This "firm," as it was known, was run as an "artist's collaborative."

Another group of creatives from the early twentieth century, included E.M. Forster, Vanessa Bell, Leonard Woolf and Virginia Woolf. They all worked together painting and writing. They were known as the Bloomsbury Group.

I believe working with another person or a group can be very rewarding and inspiring for all. The mix of different ideas and materials can spark all sorts of outcomes that neither person thought he or she could achieve on their own.

I have been lucky enough to collaborate with my partner who can create beautiful wood-turned items and make almost anything out of wood, from furniture to fruit bowls! Together we have created some lovely wooden hanging decorations, from hearts to flowers and butterflies. As he creates them out of different types of wood, I paint them and add sparkle or keep some quite simple. It's fun to experiment and see what works best. It's been a wonderful way to do something together and I'm excited to see what we create next, and whether it will be his idea or mine! The beauty is the unknown of what the other person will come up with and how you will then add to that and see how it develops.

Give working with someone else a try and join your creative skills together. You never know what may unfold.

Creativity is contagious, pass it on.

—Albert Einsteini

I can do things you cannot; you can do things I cannot. Together we can do great things.

—Mother Teresa

Index

Dedication

For my son Austin, who brings the greatest joy and magic into my life and inspires me without even knowing it. Love you x

a content + ecommerce company

Doodle Trees and Happy Bees. Copyright © 2016 by Kim Anderson. Manufactured in China. All rights reserved. No part of this book may be reproduced in any form or by any electronic or mechanical means including information storage and retrieval systems without permission in writing from the publisher, except by a reviewer who may quote brief passages in a review. Published by North Light Books, an imprint of F+W Media, Inc., 10151 Carver Road, Suite 200, Blue Ash, Ohio, 45242. (800) 289-0963. First Edition.

Other fine North Light Books are available from your favorite bookstore, art supply store or online supplier. Visit our website at fwcommunity.com.

20 19 18 17 16 5 4 3 2 1

DISTRIBUTED IN CANADA BY FRASER DIRECT
100 Armstrong Avenue
Georgetown, ON, Canada L7G 5S4
Tel: (905) 877-4411

DISTRIBUTED IN THE U.K. AND EUROPE
BY F&W MEDIA INTERNATIONAL LTD
Brunel House, Forde Close, Newton Abbot, TQ12 4PU, UK
Tel: (+44) 1626 323200, Fax: (+44) 1626 323319
Email: enquiries@fwmedia.com

DISTRIBUTED IN AUSTRALIA BY CAPRICORN LINK
P.O. Box 704, S. Windsor NSW, 2756 Australia
Tel: (02) 4560-1600; Fax: (02) 4577 5288
Email: books@capricornlink.com.au

ISBN 13: 978-1-4403-4211-0

Edited by Tonia Jenny
Designed by Elyse Schwanke
Production coordinated by Jennifer Bass

Acknowledgments

First, I have to say thank you to my wonderful mum who has been a huge support to me and always believed in my art. Thanks, also, to my sister, who is my best friend and always manages to find the right words I need to hear at the right time, even though she's across the pond, along with my very-far-away-brothers, Ross and Sean. (Love you, sibs!) My dear Nana, thank you for your amazing encouragement for all these years! And, huge heartfelt gratitude to Neil, who has been a breath of fresh air in my life and recent creativity.

To my very patient and talented editor Tonia, thank you so much for helping me achieve my dream with this book. Tonia . . . we got there in the end! Thank you to all my wonderful family and friends, especially the Taits, Karen, JJ, Kelly, Susie, Lawrence and Debra, for your constant support in my art and for having so much of it on your walls!

I am always overwhelmed by my amazing followers on social media, some who have been there since the beginning and have seen me grow, and some who have just started following my work. To each and every one of you I thank you and hope that my art will continue to give you joy and bring a little magic and sparkle into your life.

About Kim

Since graduating with a degree in textile and surface design, Kim Anderson has created an extensive portfolio of artwork for a variety of greeting card publishers, gift wrap producers, cross-stitch kits and wall art in the U.K., Europe and the United States.

Kim lives and works from her home in the creative city of Brighton with her son and their two cats.

Kim's greetings card ranges have been in the finals of the prestigious Henries Awards, the highest accolade for design talent within the U.K. card industry. She is recognized for her use of paint, pen, ink and paper collage work, which have contributed to some beautiful ranges.

Her commercial success has naturally followed her inspirational artwork and led to several collaborations with high-profile companies such as wall art for Oopsy Daisy and The Art Group, home décor with Jacqui Joseph Designs and top-selling cross-stitch kits from Bothy Threads.

Kim gets inspiration from the colors and textures in everyday life. This might include vintage objects, contemporary art, interior design or simply creative images from magazines. There are artists who have also inspired Kim including Picasso, Elizabeth Blackadder and the Bloomsbury Group. Sometimes just taking a stroll around her colorful and cultural hometown of Brighton can provide the spark that is enough to start the creative process.

kimandersonart.co.uk
etsy.com/shop/kimartwork
facebook.com/www.kimandersonart.co.uk
twitter.com/kimartwork
instagram.com/kimartwork
pinterest.com/kimandersonart

Metric Conversion Chart

to convert	to	multiply by
Inches	Centimeters	2.54
Centimeters	Inches	0.4
Feet	Centimeters	30.5
Centimeters	Feet	0.03
Yards	Meters	0.9
Meters	Yards	1.1

Ideas. Instruction. Inspiration.

Receive FREE downloadable bonus materials when you sign up for our free newsletter at ClothPaperScissors.com.

Find the latest issues of *Cloth Paper Scissors* on newsstands, or visit shop.clothpaperscissors.com

 These and other fine North Light products are available at your favorite art & craft retailer, bookstore or online supplier. Visit our websites at artistsnetwork.com and artistsnetwork.tv.

 Follow CreateMixedMedia for the latest news, free wallpapers, free demos and chances to win FREE BOOKS!

Get your art in print!

Visit **CreateMixedMedia.com** for up-to-date information on *Incite* and other North Light competitions.